The Best of Both Worlds

Finely Printed *Livres d'Artistes,* 1910–2010

THE BEST OF BOTH WORLDS

Finely Printed Livres d'Artistes, *1910–2010*

Jerry Kelly, Riva Castleman, and
Anne H. Hoy, with a Preface
by Peter Strauss

The Grolier Club · New York
in association with
David R. Godine, Publisher
Boston

Publication of this catalogue was made possible in part by grants from
The Arthur F. and Alice E. Adams Charitable Foundation and
Furthermore: a program of the J. M. Kaplan Fund.

Catalogue edited by David R. Godine, Anne H. Hoy, and George Ong.

Published in 2011 by DAVID R. GODINE · *Publisher*
 Post Office Box 450
 Jaffrey, New Hampshire 03452
 www.godine.com

Library of Congress Cataloging-in-Publication Data
The best of both worlds : finely printed livres d'artistes, 1910–2010 / with an
introduction by Jerry Kelly; foreword by Riva Castleman, & preface by Peter Strauss.
 p. cm.
Published to accompany an exhibition curated by Riva Castleman, Anne H. Hoy &
Jerry Kelly held at the Grolier Club, N.Y., May–July 2011.
Includes bibliographical references and index.
ISBN 978-1-56792-431-2
 1. Artists' illustrated books—Exhibitions. I. Castleman, Riva. II. Hoy, Anne H. III.
 Kelly, Jerry, 1955– IV. Grolier Club. V. Title: Finely printed livres d'artistes, 1910–2010.
NE890.B47 2011 769.9'040747471—dc22 2010045910

FIRST EDITION

Printed in China

Contents

THE ART OF THE BOOK UNITES TWO OF MAN'S MOST CHERISHED GOALS. THE PRESERVATION OF KNOWLEDGE IS LINKED WITH PRESENTATION OF THE NOBLEST POETRY AND PROSE IN FORM CONSISTENT WITH THE SIGNIFICANCE OF THE WORDS. *– Joseph Blumenthal*

TO CREATE A UNITY FROM THESE . . . ELEMENTS IN SUCH A WAY THAT THE RESULT IS NOT A PASSING PRODUCT OF FASHION, BUT ASSUMES THE VALIDITY OF PERMANENT VALUE – THAT IS OUR DESIRE. . . . THE SINGLE PURPOSE OF THESE BOOKS IS TO TAKE THEIR PLACE WORTHILY IN THE GREAT HERITAGE OF WHICH WE ARE STEWARDS. *– Giovanni Mardersteig*

THESE BOOKS ARE, AT THEIR BEST,
INTERNATIONAL ASSETS OF INTRINSIC
VALUE. . . . SUCH BOOKS, CAREFULLY
PRODUCED AND WELL ILLUSTRATED,
ARE ENDS IN THEMSELVES, AND NO
LESS WORTHY OF ATTENTION
THAN ANY OTHER ARTISTIC
PRODUCTIONS. *– John Buckland Wright*

I MAKE NO DIFFERENCE
BETWEEN THE CONSTRUCTION OF
A BOOK AND THAT OF
A PAINTING. *– Henri Matisse*

WHAT MATTERS IS THAT
A BOOK HAVE ALL THE DIGNITY
OF A MARBLE SCULPTURE. *– Joan Miró*

Preface

I started my collection of *livres d'artistes* thirty-two years ago. At the time, I was struck by the superb art contained in the volumes – woodcuts, etchings, and lithographs – as well as the collaborations between artists and writers. That was my focus. Several years later, I questioned myself: "Is it not possible that my background as a printer and accumulated knowledge of design, typography, paper, and, of course, printing inspired my attraction to *livres d'artistes?*" The answer was "yes," and now I look at these books from a different perspective and in a new light. Suddenly the dimensions and horizons were expanded.

Some of the *livres d'artistes* on display in this volume and in the exhibition it accompanies have a place in my collection and I have selected a few to illustrate how design, typography, and paper are integrated into the magnificence of these books. Matisse, who proclaimed "I make no difference between the construction of a book and that of a painting," created etchings for the outstanding *livre d'artiste Poésies* by Mallarmé (1932, no. 16). Large red initials appearing at the beginning of the black text are counter-balanced by the full-page etchings on facing pages. Matisse also selected the font. Let the artist speak for himself: "…the design fills the unmargined page, for the design is not, as usual, massed towards the center but radiates over the whole sheet…." The sculptor Aristide Maillol (1926, no. 4) developed the textured deckle-edged paper for his own books with his nephew. The layout and margins of these books are a marvel of book design.

Another great *livre d'artiste* is *Maximiliana* with engravings by Max Ernst (1964, no. 39). The distinctive design is the work of the multi-talented Russian-French poet/ designer/typographer/publisher Iliazd. The whimsical Surrealist-inspired typography, original and eccentric, the parchment cover, and the placement of five blank pages of fine-textured deckle-edged paper at the front and back of the book lend uncommon originality to the overall design.

Apocalypse with woodcuts by Jim Dine (1982, no. 54) is a *livre d'artiste* of exceptional design, printed on fine paper, with a wooden cover created by Dine. Seldom have artists of *livres d'artistes* designed beautiful covers for their books – though particular mention must be made of *Theogonie* by Braque (1955, no. 32) whose exceptional slipcase and cover are the creation of the artist, and the most important Expressionist

book – *Umbra Vitae* by Kirchner (1924, no. 2) – which has a cover designed by the artist with a woodcut in the center.

It is, therefore, evident that typography, design, and paper play a crucial part in the production of *livres d'artistes*. The focus of this book and exhibition on these elements introduces us to these occasionally overlooked aspects of *livres d'artistes*. I, as a printer and collector, am fascinated.

Peter Strauss

Foreword

This exhibition of illustrated books emphasizes how their components – from paper to print, from well-designed typography to imaginative imagery in a myriad of printing techniques, from woodcut, lithograph, and etching to photography – come together in a balanced and aesthetically pleasing whole. In making a selection of books printed and published in the past one hundred years, the proponent of the theme of this exhibition, Jerry Kelly, and I each compiled lists of what we thought were the finest and most successful illustrated books. Kelly, a designer who has elevated the values of fine printing in his own work, had felt that certain elements in illustrated books should have balance as well as defined impact. Clarity was essential in both typography and imagery; they had to match well on the pages they occupied. Some of the seventy-seven books displayed here may not achieve the teeter-totter balance we sought. On occasion, the matching of elegant paper with delicate typography has produced facing pages that float away from a vivid image. The artist's composition may overwhelm text that is printed from very fine type, thereby forcing the viewer to seek what the "best" means – a word used deliberately in the title of this exhibition catalogue.

Among the books of the past forty years the balance has shifted. Design styles have become broader. Some un-inked, embossed elements have transformed the texts and illustrations by altering the expected flattened beauty of handmade paper: for example, Gunther Uecker's scattered nails create the overall inkless embossing in his book *Vom Licht* (1973, no. 50). Or etched plates have carried to the page their outlines as well as the artist's composition. Robert Motherwell's interpretation on very heavy paper sheets of *A la Pintura* (1972, no. 48) consists of one etched plate in the appropriately translated color noted in that page's text.

Luckily, the writing of a foreword to an exhibition catalogue not only must follow the diversity inherent in illustrated books, but also must survey a partly-plowed territory. Without disrupting the seriously studied compilation of "The Best of Both Worlds," some of the alternative points of view that surround the assessment of the "best" can be unveiled. The most difficult decisions have rested on putting aside many long-term theories about the confrontation of word and image . . . whether in art galleries where signage is often overstated, or in a book where the pictures may

not "illustrate" the text. Both author (protected by the design of his or her text by the printer) and fine artist have visualized their work together, but rarely have they been celebrated for accepting each other as a creative equivalent.

The "best" years are those when authors and artists know each other well and choose to collaborate on a project that is envisioned and carried through with equal enthusiasm and dedication. Between the 1890s and 1920s and the 1940s and 1990s, artists and authors were seriously chummy, and it is in these books that the "best" shines. While some illustrated books have documented events of their time that now have significant historic meaning, their literary and visual content rarely incorporates the elegance that printers believe is an important qualification of the "best" printing. The French terminology *livres d'artistes* focused on the image maker, not the printer. The result has been a battle in recent decades between the printer's concept of the design of text and production, and the artist's inspiration. The impasse that has arisen between fine printing and commercial typography has to lead to other ways of judging the quality of bookmaking by artists whose image making has little association with an earlier world.

<div align="right">Riva Castleman</div>

Introduction

Sometime shortly before 1900, so the story goes, the French art dealer Ambroise Vollard was riding a bus in Paris when he overheard a conversation about the work of the poet Paul Verlaine. This led Vollard to conceive of publishing a book of Verlaine's poems, illustrated with original prints by a prominent artist. He initially wished to commission woodcuts by Lucien Pissarro, son of the painter Camille Pissarro, but this did not work out. Then Vollard approached Pierre Bonnard, one of the artists he exhibited at his gallery. The result was *Parallèlement*, a book with Bonnard's lithographs printed in a dusty rose-red, surrounding Verlaine's poems typeset and printed by the Imprimerie Nationale in the italic type of Jean Jannon (often referred to as Garamond, but actually an eighteenth-century font). Many consider this collaboration of artist, writer, and printer, all under the tasteful direction of an inspired impresario, to be the first modern *livre d'artiste*, though there were precursors in books illustrated by Manet and Delacroix, and even earlier in works by Blake and Dürer. *Parallèlement,* however, set the standard for a continuous stream of a special genre of book, wherein original prints by a major artist accompany a substantial text, often specifically written for the publishing project. In the decades that followed *Parallèlement* – indeed for over a century, and right up to the present day – nearly all artists of note have applied their talent to a specially produced limited-edition book.

Some years earlier, across the channel in London on November 15, 1888, William Morris had the idea of starting a private press. The subject came up while he was strolling home with Emery Walker, after the latter's lecture on the history of printing. Within a few years Morris would design his own typeface; arrange for the making of a special handmade paper based, like his type, on historical models; and assemble a staff of compositors and pressmen capable of producing a fine book. The year 1892 marked the first publication of Morris's Kelmscott Press (named for the house where Morris lived), a work by Morris himself titled *The Story of the Glittering Plain.* Over fifty more volumes were subsequently printed by the Kelmscott Press – volumes that set a new standard for fine printing and craftsmanship.

The Kelmscott Press, generally acknowledged as the start of the modern fine printing movement, was quickly followed by the Ashendene Press and Doves Press, both in London. Soon the movement spread, leading to the Bremer and Cranach presses in Germany, and the Village and Elston presses in America, as well as numerous others.

Importantly, the standards of craftsmanship and design established by these small, private operations influenced commercially produced editions.

We could note a couple of common denominators, each quite unusual for the time, between Vollard's edition of *Parallèlement* and the Kelmscott Press volumes: both use the finest materials (such as handmade paper and carefully selected, rare – if not unique – fonts like the Kelmscott Press's proprietary Chaucer and the so-called "Garamond" types of the Imprimerie Nationale); and, for both the design of the pages is conceived as two-page spreads, not individual leaves. One would be very hard-pressed to find these characteristics in other volumes printed around the turn of the nineteenth century.

The finely printed *livres d'artistes* in this volume contain prints by great artists of the one hundred years from 1910 to 2010, including, among others, Picasso, Braque, Matisse, Rouault, and Miró, who have devoted some of their finest efforts to the art of the book. It should be no surprise that major artists have applied themselves to the codex format: throughout history there are countless examples of collaborations among artists, whether it be painters or sculptors applying their skills to architecture, writers contributing librettos for operas, or other such symbioses. That fine art and bookmaking – two apogees of human culture – should meet often is almost to be expected, given artists' respect for a broad range of cultural activity.

There is no shortage of catalogues of great *livres d'artistes* from the twentieth century and beyond, and also no lack of catalogues of examples of fine printing from the same period. One can cite the landmark 1960 Boston Museum of Fine Arts catalogue *The Artist and the Book, 1860–1960*, Riva Castleman's catalogue of the Museum of Modern Art exhibition *A Century of Artists Books*, or the Bayerische Staatsbibliothek's catalogue *Papiergesang*, as examples of the former; with Stanley Morison's *Modern Fine Printing* and The Grolier Club's *A Century for the Century* being examples of the latter. There are many others in both categories. However, there has never been an exhibition or catalogue that explored the overlap of these facets of bookmaking: the intersection of fine book production and great artwork in books printed in an edition of fifty or more copies. Under the umbrella of fine bookmaking we include paper (usually mould-made or handmade), presswork (almost exclusively letterpress for the text, often combined with various intaglio techniques or serigraphy for the images), layout and typography, and binding, as well as overall care and skill in combining these disparate elements into a cohesive whole. Great artwork includes prints (most often woodcuts, etchings, or lithographs, but also serigraphs, photographs, and other methods of print making, sometimes including hand coloring or even collage) by fine artists.

By confining ourselves to the overlap of the two arts of fine bookmaking and artist's prints, we have had to leave out a number of significant volumes: many a finely printed book contains artist's prints that are not first-rate; just as many books containing beautiful artwork fall short in their design and production values. Books from each group can be cited as examples: for instance, Matisse's *Jazz* is one of the greatest (if not *the* greatest) *livres d'artistes* of the period under consideration here, yet the bookmaking attributes of this set of unbound sheets with handwritten text eliminate it from consideration as a truly fine piece of bookmaking. Exceptional specimens of fine printing have not been included if the artwork fell short of the standard established during this phenomenally productive period. Similarly, finely printed books – such the Officina Bodoni edition of Ovid's *Amores* or Hermann Zapf's *Manuale Typographicum* – that contain no original prints whatsoever are therefore not eligible for inclusion.

There is a long tradition within the field of *livres d'artistes* of issuing a book in loose gatherings of folded sheets, with the intention that the owner will later have the book bound in a fine, appropriate – and individual – manner. This tradition was partially due to the collector's putative desire to have the book bound to his or her taste, and partially because the expense of an elaborate binding for an edition of one hundred copies or more can be prohibitive, unless extraordinary capital is available to the publisher. The tradition seems valid to us: better to leave for later the binding of a book with great artwork than to publish it in a second-rate binding. Therefore, we were not reluctant to include unbound volumes in this selection.

The essence of fine bookmaking is the bringing together of disparate elements to form a harmonious whole. In the best examples, paper, font, layout, presswork, and binding are all superlative; but it is not sufficient that these various factors all be of the highest quality. In order for a book to reach the highest echelons of the art, every attribute must interact with each of the others to make for a whole that is greater than the sum of its parts; and then the whole must still be appropriate for the given text – and, if applicable, the artwork contained within the volume. Many an otherwise fine book was not included in this selection because just one of these essential elements fell short of the ideal. For example, even if font, presswork, paper, and binding were fine and suitable to the text and images, a book was not included if the margins were inadequate. Similarly, the margins and other elements could all be of the highest caliber, but this would not make for a truly superlative book if the paper were not of high quality.

The appropriateness of any element in a finely produced volume to the overall book

trumps the "absolute" beauty of a single facet. Hence, a less-than-perfect typeface might be just right in a particular setting, as is the case with the rather crude Pen Print Bold font used in The Spiral Press edition of *Primitives,* with poems and woodcuts by Max Weber (1926, no. 6). Indeed, an elegant typeface like Garamond or Baskerville (each of which is used in more than one book in this catalogue) would be totally inappropriate for Weber's rugged woodcuts. Similarly, just about every book in this selection is printed on a sensual mould-made or handmade paper, but for *Facile,* with its modern, boldly cropped, full-bleed photographic images by Man Ray (1935, no. 18), such a paper would be totally unsuitable. Hence that volume is quite harmoniously printed with both type and photographs on machine-made paper.

It could well be argued that what makes one piece of art great and another average is somewhat subjective. Still, just as it is hard to doubt the greatness of paintings such as Picasso's *Guernica* or Matisse's *The Piano Lesson,* it is next to impossible to underrate the beauty of the etchings by the former for Ovid's *Les Métamorphoses,* or by the latter for Mallarmé's *Poésies* (1931, no. 13; 1932, no. 16). Amazingly, these two superlative *livres d'artistes* were the initial publications of Albert Skira.

There are several examples of *livres d'artistes* that have previously been included in virtually every major exhibition of the genre omitted here because the *bookmaking* qualities failed to meet the highest standards: they could not be considered the best of *both* worlds. Indeed, quite a few books that we (and numerous others) greatly admire for their artwork could not be included, because we have to be honest about their shortcomings as examples of fine *bookmaking.* This may seem subjective, but if considered objectively I hope the selection will not be deemed arbitrary or biased. To give one prime example, the Vollard edition of Balzac's *Le chef-d'oeuvre inconnu* contains magnificent prints by Picasso, and is included in every catalogue of great *livres d'artistes,* but the curators felt there were several significant flaws in the production of this important volume, so it was omitted from our selection. Later, while researching the commentaries included in the pages of this catalogue, I was heartened to come across the following assessment of the book by the great French dealer and collector Pierre Berès (published in 1991 by the Library of Congress in *Vision of a Collector: The Lessing J. Rosenwald Collection):*

[Picasso] let Vollard have twelve beautiful etchings, at the outside just adaptable to the novel. Still, the fact that eleven of them were horizontal reinforced their lack of appropriateness to the book. . . . He also gave Vollard sixty-seven drawings, all as beautiful as they were without the slightest relation to the text. The delighted dealer had these translated into wood engravings and dispersed amid the pages. He also yielded to Picasso's request to use, "en matière

d'introduction," a series of fifty-seven abstract dot-and-line drawings, many of which had been previously published as unambitious varia. In this unexpected and incomprehensible "introduction," Picasso was somehow following the example of Balzac, who had often mystified readers with pages of marks. He intended to make fun of those neophytes who were in open-mouthed, if uncomprehending, admiration of whatever he did. He probably also wanted to protest against the surprising preface that his industrious publisher had asked Albert Besnard to write. Besnard was a fashionable painter of prewar years who had accumulated all possible honors, from the Académie Française to the Beaux-Arts, presiding over juries of all the salons, for many of which Vollard needed his cooperation. Besnard's poor preface was an outrage among the prestigious presences of Balzac and Picasso.

The resulting book, a strange combination of a great text, an insignificant preface, and beautiful etchings and drawings – abstract or not – was successful. This was partly because Vollard relied entirely on the printer. Aimé Jourde's typography is undistinguished – Vollard never cared much about that – and certainly not the better for being married to Picasso's lines, but it is quite honest, and the layouts make the best of the hodgepodge. The public, a throng of speculative rapacious book-buyers, entirely dumb to Picasso's nearly disdainful demeanor, praised the book and bought it eagerly. . . . *Le chef-d'oeuvre inconnu* . . . marked the end of Picasso's indifference to book illustration. Soon afterward, under Skira's spell, he illustrated Ovid's *Metamorphosis* and thereafter continued adorning books.

Undistinguished typography / a hodgepodge / artwork unrelated or just barely relevant to the text, and printed in the improper orientation to the page: this is a laundry list of bookmaking faults, and it supplies the reasons why we had earlier decided that, despite its great prints, *Le chef-d'oeuvre inconnu* did not meet the criteria of "The Best of Both Worlds."

By using the phrase "the best of both worlds" we do not mean to imply that the seventy-seven selections in this catalogue are the greatest possible examples of the genre. Instead we use the phrase as an idiom, meaning that these volumes draw from the finest attributes of two worlds: the skill, craft, and taste of the fine presses, as well the category of *livres d'artiste*. All the books shown in these pages are indeed exceptional when judged on these grounds. However, despite the efforts of the curators to choose particularly fine examples, we do not claim to have found the best of *all* possible options. As mentioned above, there are some (but very few) artists who have never created artwork for books, and there are also some (but again very, very few) printers of any significance who have never produced books containing important original graphics. For example, the Bremer Press produced among the best designed and printed editions issued in Germany between the two World Wars, but only a couple of relatively unimportant volumes contained original illustrations. The important printer Victor Hammer virtually never used graphics other than an

Syr Ysambrace. London: The Kelmscott Press, 1896. A representative book from the prototypical private press. Set in Morris's Chaucer type and printed on Barcham Green handmade paper at his Kelmscott Press. Illustration by Edward Burne-Jones; border and initial designs by Morris.

occasional woodcut or engraving that he himself had created for a book, and the great American book designer Bruce Rogers rarely worked on books illustrated with original art prints. Still, these are rare exceptions: most modern book designers have worked on several *livres d'artistes* (as have most modern artists). Yet the overlap of the *finest* productions of artist and bookmaker is surprisingly rare.

A fine book is a complex and sophisticated object. No one person could ever hope to master all of the assorted skills associated with fine books, which range from paper-making, typography, and presswork to layout and binding – though Dard Hunter came tantalizingly close. Hunter, a talented papermaker, cut and cast his own font of type, from which he printed several books on a handpress, which he then bound with his own hands. Hunter was an authority on handmade paper and himself a master of that demanding craft, but his typeface – while an achievement – would not be considered a prime example of the type designer's art. Hunter's presswork and binding were certainly on a par with many of the better practitioners of those crafts, but he never worked on a *livre d'artiste*; instead he devoted his greatest efforts to books about his beloved craft of papermaking. So there is no one who has excelled at *all* the assorted skills necessary to produce a great *livre d'artiste*, and we should not find this surprising: each of the various crafts involved in the production of an exceptional artist's book requires many years to master. Therefore, all great books are a collaboration.

When exceptional artists and practitioners from a broad range of bookmaking skills come together, then the final product may be considered a fine edition. Such was the

case with, for example, the Cranach Press edition of Virgil's *Eclogues* with woodcuts by Aristide Maillol (1926, no. 4) – a classic example of a *livre d'artiste* that utilizes the finest book-making elements. Artisans practicing various crafts in three countries joined forces in making this superlative edition: the text type for the book was specially made for the exclusive use of the Cranach Press under the supervision of Emery Walker (who had previously consulted with the great British private presses such as Kelmscott and Ashendene, and who was himself a partner at the Doves Press). The roman font, based on the work of Nicolas Jenson, was cut by hand by Edward Prince (who also cut types for many of the above-mentioned private presses). Walker also supervised the cutting by Prince of a supplemental italic font (used in the lengthy colophon of the *Eclogues*) based on the types of Giovanni Tagliente. As a further distinction, this latter font was worked on by Edward Johnston, the father of modern calligraphy. The sumptuous handmade paper for the book was specially developed in France by Count Kessler, Aristide Maillol, and Maillol's nephew Gaspard. The book's exceptionally careful typesetting was supervised by John Mason, who worked for years at the Doves Press. Another craftsman from the Doves Press, Crosby Gage-Cole, joined a German pressman in printing the book on a handpress. All of this was overseen by the director of the Cranach Press, Count Harry Kessler, who initially approached Maillol (most famous for his sculpture) to create woodcuts for this special edition. Maillol accepted the offer, and even travelled with Kessler to Greece for the proper Mediterranean inspiration.

Of course, such efforts take time and it was many, many years before the volume was completed: the project was begun before World War I and not finished until

1926. Far from being unique, such lengthy gestation periods are not terribly uncommon for the finest *livres d'artistes*: other books in this catalogue, such as the Ovid with prints by Picasso, the Mallarmé illustrated by Matisse, and the Hesiod with etchings by Braque, were all in production for a decade or more before being published. As with the Cranach Press Virgil, and indeed every other volume in this catalogue, the result is a masterpiece of the book arts.

For the commentary on most of the individual books in this selection the unusual choice of using excerpts from previously published texts has been made, rather than writing anew about virtually every entry. We have done this for several reasons: most obviously, a single voice can become monotonous and possibly repetitive when applied to over seventy books, particularly when those books are all of the same genre (in this case modern fine editions illustrated with art by major artists). In addition, the viewpoint of many experts helps to reinforce the selections made by the curators. Another major advantage of quoting from various sources is that it offers the opportunity to provide assorted unique insights into the editions included here. Often recollections are presented from an individual who played a major role in the production of the book under consideration, from artist (for example, Henri Matisse/*Poésies* and Joan Miró/*A Toute Épreuve*) or printer (such as Joseph Blumenthal/*Primitives* and Kim Merker/*A Continuous Life*) to publisher (as with Douglas Cleverdon/*The Rime of the Ancient Mariner* and George Macy/*Main Street*). Occasionally, commentary about a specific book in this exhibition was written by another practitioner represented with a selection in "The Best of Both Worlds." For instance, Gunnar Kaldewey, whose edition of Pasolini's poems with art by Not Vital appears as no. 60, writes insightfully about the Cranach Press Virgil with woodcuts by Maillol; and Joseph Blumenthal – whose Spiral Press printed five books in this catalogue, more than any other printer – comments on Claire Van Vliet's Janus Press (no. 47). We hope that this approach will make this catalogue more stimulating and informative for the reader.

The work of Vollard and Morris inspired an outpouring of *livres d'artistes* and fine editions that continues to the present day. On numerous occasions the principles of both the *livre d'artiste* and the fine press edition have overlapped, resulting in a volume that can hold its own among prime examples of each group: fine printing *and* books illustrated with exceptional prints. When such a confluence occurs, as it does in the nearly eighty books that follow, surely it can be considered the best of both worlds.

Jerry Kelly

ACKNOWLEDGMENTS

Numerous people have assisted with this publication; we apologize if we could not include them all in these brief acknowledgments.

Collectors, institutions, and publishers who graciously lent books to the exhibition are listed below. The Grolier Club staff, including director Eric Holzenberg, exhibitions coordinator Megan Smith, as well as Tammy Rubel and Maev Brennan, provided valuable assistance. David R. Godine, Publisher, graciously agreed to act as co-publisher with The Grolier Club. Generous grants toward this publication were provided by The Arthur F. and Alice E. Adams Charitable Foundation; and Furthermore: a program of the J. M. Kaplan Fund.

Important suggestions regarding the text of this book were made by Boris Fridman, David Godine, Peter Kraus, George Ong, Peter Strauss, Jake Wien and Bill Wyer. Mehera Bonner worked tirelessly to secure permissions. Assistance with loans and photography was provided by Emily Talbot and Gretchen Wagner at MoMA; Virginia Bartow, Andrea Felder, Jessica Pigza, and Thomas Lisanti at the NYPL; Liam Shaefer at ARS; as well as Dieu Donné, James Jaffe, and Robert Lorenzson. Lisa Baskin, Antonio Frasconi, Eric Fischl, Peter Blum, and others generously allowed artwork to be reproduced in this volume. Specific photo credits appear at the end of the book.

We consulted with Peter Blum, Jason Dewinitz, Vincent FitzGerald, Boris Fridman, Eric Holzenberg, Peter Kraus, Julie Melby, Leslie Miller, Elizabeth Phillips, Luke Ives Pontifel, Peter Strauss, William Wyer, and others regarding various aspects of this project.

We extend our sincere thanks to all these and many others who have made *The Best of Both Worlds* possible.

RC · AHH · JK

LENDERS TO THE EXHIBITION

Anonymous
Peter Blum / Blumarts
Dieu Donné
Vincent FitzGerald & Company
Boris Fridman
The Grolier Club
Nancy Leo-Kelly
The Museum of Modern Art
The National Gallery of Art
Elizabeth Phillips
Andrea Stillman
Peter Strauss
Jake Wien

The Best of Both Worlds

Finely Printed *Livres d'Artistes,* 1910–2010

NOTES TO THE CATALOGUE

Measurements are page size (not binding size) to nearest ¹⁄₁₆ inch. Almost all pages are irregular owing to deckle edge paper.

Many of these books were issued in sheets; bindings vary. Most reproductions show facing pages, as in the original books. Where that was not practical, an image page and a text page are shown from different sections in the book; those pairings are marked with an asterisk [*] at their lower right.

The observations about each book's production on the left-hand pages are by Jerry Kelly.

1. Wassily Kandinsky, KLÄNGE

R. Piper & Co., Munich, [1913]

Woodcuts
by Wassily Kandinsky
(1866–1944).

300 copies.

Set in Akzidenz Grotesk type and
printed by Poeschel & Trepte,
with color woodcuts printed by
F. Bruckmann, on Van Gelder paper.

11 1/16 x 10 7/8 in.

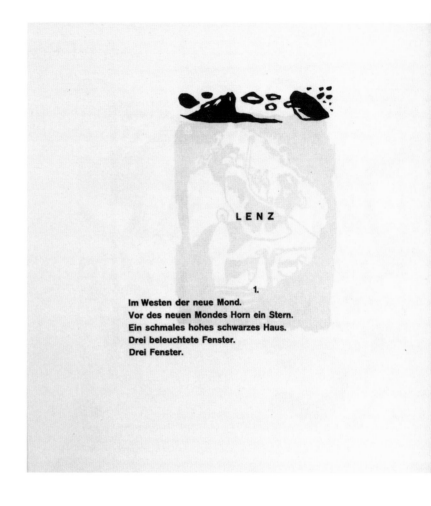

LENZ

1.

Im Westen der neue Mond.
Vor des neuen Mondes Horn ein Stern.
Ein schmales hohes schwarzes Haus.
Drei beleuchtete Fenster.
Drei Fenster.

*The graphic, heavy "monoline"
(sans serif) Akzidenz Grotesk font is
a good match for the bold, graphic
woodcuts by Kandinsky. Both the type
and the semi-abstract style of woodcut
engraving were relatively new at the
time of publication.*

... *Even in the years before 1914 work by professional illustrators, reproduced by photography, begins to be overshadowed, at least in retrospect, by prints in the new, experimental styles. Among these were several Cubist etchings by Picasso, superlative woodcuts by Dufy ... and abstract illustrations by Kandinsky.*

– T. M. MacRobert, *Fine Illustrations in Western European Printed Books.* London, Her Majesty's Stationery Office [Victoria & Albert Museum], 1969.

2. Georg Heym, UMBRA VITAE

Kurt Wolff Verlag, Munich, 1924

Woodcuts
by Ernst Ludwig Kirchner
(1880–1938).

510 copies.

Designed by Kirchner and printed by
Spamerschen Druckerei on cream
laid paper (10 copies on Japan paper).

9¹⁄₁₆ x 6⅛ in.

*Here again the sans serif font (in an
even bolder weight than in the previous
entry) complements the images, which
in turn are bolder than Kandinsky's.
Woodcuts appealed to the German Ex-
pressionists for their associations with
both medieval and folk art traditions,
as well as their expressive directness.*

SPITZKÖPFIG KOMMT ER...

Spitzköpfig kommt er über die Dächer hoch
Und schleppt seine gelben Haare nach,
Der Zauberer, der still in die Himmelszimmer steigt
In vieler Gestirne gewundenem Blumenpfad.

Alle Tiere unten in Wald und Gestrüpp
Liegen mit Häuptern sauber gekämmt,
Singend den Mondchoral. Aber die Kinder
Knien in den Bettchen im weißen Hemd.

Meiner Seele unendliche See
Ebbet langsam in sanfter Flut.
Ganz grün bin ich innen. Ich schwinde hinaus
Wie ein gläserner Luftballon.

13

In 1912 the Rowohlt Verlag in Leipzig published the first edition of the posthumous poems of Georg Heym. The suggestion that these poems be re-published by Kurt Wolff with woodcuts by Kirchner goes back to Hans [Giovanni] Mardersteig, who lived at the time in Davos, and worked for the Kurt Wolff Verlag. In a letter from the end of February 1922 Mardersteig wrote to Wolff: "Over the course of several years now, Kirchner has spent some of his leisure time illustrating Heym's Umbra vitae for his own pleasure. . . . He has supplemented the old edition with . . . small woodcuts added under each of the poems." Two years later the book was printed by the Spamerschen press in Leipzig, and published by Kurt Wolff in Munich. The entire book design and layouts were exactly as specified by Kirchner, who also created the cover design and cut it in wood.

– Ralph Jentsch, *Illustrierte Bücher des deutschen Expressionismus.* Stuttgart, Edition Cantz, 1989.
[Translated from the German]

3. [The Holy Bible], GENESIS

The Nonesuch Press, London, 1924

Wood engravings
by Paul Nash
(1889–1946).

375 copies.

Designed by Francis Meynell,
printed from Neuland type by the
Curwen Press on Zanders paper.

10⁷⁄₁₆ x 7½ in.

MOVETH UPON THE EARTH + AND
GOD SAID BEHOLD I HAVE GIVEN
YOU EVERY HERB BEARING SEED
WHICH IS UPON THE FACE OF ALL
THE EARTH AND EVERY TREE IN
THE WHICH IS THE FRUIT OF A TREE
YIELDING SEED TO YOU IT SHALL
BE FOR MEAT + AND TO EVERY
BEAST OF THE EARTH AND TO
EVERY FOWL OF THE AIR AND TO
EVERY THING THAT CREEPETH
UPON THE EARTH WHEREIN THERE
IS LIFE I HAVE GIVEN EVERY GREEN
HERB FOR MEAT AND IT WAS SO +
AND GOD SAW EVERY THING THAT
HE HAD MADE AND BEHOLD IT
WAS VERY GOOD AND THE EVEN—
ING AND THE MORNING WERE
THE SIXTH DAY

*At the time this edition was printed
wood engravings were generally han-
dled in a somewhat conservative, real-
istic style, but Nash's abstract cuts for
the Nonesuch Press edition of Genesis
break the mold, representing the concept
of creation in a novel manner. The crude
Neuland font matches the engravings in
its "color" and hand-cut appearance.*

H

Paul Nash's interest in book illustration ante-dates the First World War, though he was initially unable to gain work of this kind. . . . At the end of 1923, he was asked by the newly-founded None-such Press to provide illustrations for Genesis, *and these are held to be the first sign of mastery of woodcutting, a medium he had begun to explore in 1918. The cancelled woodblocks for this edition are held by the V&A. The None-such Press was established by Francis Meynell, David Garnett and Vera Meynell in 1923; their use of established commercial presses such as the Curwen Press was designed to keep the prices of their limited editions as low as possible.*

– Carol Hogben and Rowan Watson, *From Manet to Hockney: Modern Artists' Illustrated Books*. London, Victoria & Albert Museum, 1985.

4. Virgil, THE ECLOGUES

The Cranach Press, Weimar, 1926

Woodcuts
by Aristide Maillol
(1861–1944).

264 copies: 33 on Japan paper with
suite, 6 on vellum with an additional
suite of the prints (English edition);
304 copies: 36 on paper made from
Chinese silk fiber with suite, 6 on vel-
lum with suite (German edition); 292
copies: 36 on paper made from
Chinese silk fiber with suite, 6 on
vellum with suite (French edition).

Designed by Count Harry Kessler,
printed at the Cranach Press on paper
handmade by Gaspard Maillol from
the Cranach Press's Jenson roman
and Tagliente italic types.
Calligraphic title by Eric Gill.

12¹⁵⁄₁₆ x 9¹¹⁄₁₆ in.

P. VERGILI MARONIS ECLOGA PRIMA
MELIBOEUS ET TITYRUS

INCIPIT MELIBOEUS
TITYRE TU PATULAE RECUBANS SUB
TEGMINE FAGI, SILVESTREM TENUI MU
SAM MEDITARIS AVENA: , NOS PATRIAE
FINIS ET DULCIA LINQUIMUS ARVA.
NOS PATRIAM FUGIMUS : TU TITYRE
LENTUS IN UMBRA , FORMOSAM RE
SONARE DOCES AMARYLLIDA SILVAS.

4

*There can be no finer marriage of text
and image than this Cranach Press
volume, combining Maillol's elegantly
classical expression of the ancient wood-
cut medium with a re-cutting of the
lovely fifteenth-century Jenson typeface.*

30

P. VERGILIUS MARO: FIRST ECLOGUE
MELIBOEUS AND TITYRUS

ELIBOEUS: Tityrus, lying at ease in the shade of the beechwood tree, you play over and over again on your slender pipe a rustic song. Our sad lot is to leave our homeland, and the fields we loved, and to wend our way to a foreign land. You, at your ease in the shade, fill the woods with your songs of the lovely Amaryllis.

TITYRUS: Friend Meliboeus, it was a god, who granted me this happy ease. Yes, I will ever worship him as a god, and his altar shall oft-times redden with the sacrifice of a tender lamb from my sheepfold. By his gracious will my cattle pasture freely, as you see, while I spend the time playing my favourite tunes on a rustic reed.

MELIBOEUS: I do not envy your happiness, only marvel; for on all sides far and near there is confusion in the countryside. Look at me, ill in myself I drive on my goats, and I wearily drag this one along. Poor thing! Just a little while ago she bore twins among the hazel thickets, the finest hope of my flock. Alas! we left them on the flinty wayside. Yet I remember the oaks struck by lightning would often have warned me of this disaster, if I had not been blind to the omens. But tell me, Tityrus, who is he whom you call a god? TITYRUS: Meliboeus, in my stupid ignorance, I

5

One sees in the book with what care they labored for many years: a disruption due to the war years is imperceptible. Everything has a vibrant unity and mirrors the bucolic mood of the Eclogues, a glorification of country life. The paper has an especially beautiful pearl gray tone with a somewhat raw surface.... What resulted was not a German, but rather a European artist's book. Corresponding to the life of the impresario of the Press, who frequently traveled back and forth by night train between Berlin, Paris, and London, the paper and illustrations came from France, the type was created in England, and the production took place in Germany.

– John Dieter Brinks, in *The Book as a Work of Art: The Cranach Press of Count Harry Kessler.* Laubach and Berlin, Triton Verlag, and Williamstown, MA, Williams College, 2005.

5. Jean Giraudoux, Paul Morand, Pierre Mac Orlan, André Salmon, Max Jacob, Jacques de Lacretelle, and Joseph Kessel, LES SEPT PÉCHÉS CAPITAUX

Simon Kra, Paris, 1926

Etchings
by Marc Chagall
(1887–1985).

300 copies: 16 on Japan paper with an additional suite of the prints; 44 on Holland paper with suite.

Etchings printed by Louis Fort, with text printed by L'Imprimerie Coulouma.

10¼ x 7 ¹¹⁄₁₆ in.

These early etchings by Chagall are representational, with a definite modern twist. The typography, too, is handled in a fresh way; both are appropriate for the newly written texts on the oft-repeated theme of the seven deadly sins.

LES SEPT PÉCHÉS CAPITAUX

JEAN GIRAUDOUX
L'ORGUEIL

· · PAUL MORAND · ·
L'AVARICE

PIERRE MAC ORLAN
LA LUXURE

· · ANDRÉ SALMON · ·
L'ENVIE

· · MAX JACOB · ·
LA GOURMANDISE

JACQUES DE LACRETELLE
LA COLÈRE

· · JOSEPH KESSEL · ·
LA PARESSE

EAUX-FORTES DE MARC CHAGALL

SIMON KRA, 6, RUE BLANCHE, PARIS

The folkloric floating figures and whimsical animal-human hybrids that Chagall depicted throughout his long career are especially apropos here, in Simon Kra's modern take on a medieval theme. In his frontispiece Chagall stacks gentle personifications of the deadly sins on an artist's head, and one might think the humanistic painter-printmaker is identifying himself among them, perhaps as Pride, full-length at his easel. He may be proud of his godlike imaginative gifts (he had been welcomed by the Paris vanguard soon after his arrival from Russia in 1910). Or the stack of sins may imply he sees himself as capable of all of them, like any mortal. On the title page opposite appears another stack, of bold and italic lines, and the justified type forms the shape of a column-with-capital, perhaps an embodiment of the capital sins described and visualized within. Chagall's affection for books and printmaking bore fruit in over a hundred books, albums, and catalogues, including forty-five livres d'artistes from 1960 to 1969.

– Anne H. Hoy

6. Max Weber, PRIMITIVES

E. Weyhe, New York, 1926

Woodcuts (printed from electrotypes)
by Max Weber
(1880–1961).

350 copies.

Designed by Joseph Blumenthal and
printed from Pen Print Bold type at
The Spiral Press on English hand-
made paper.

10 x 6⅛ in.

*Often a skillful designer can employ an
otherwise unattractive element in an ef-
fective way. Such is surely the case with
the Pen Print Bold typeface used for this
volume of Weber's cubist woodcuts: the
type is a good match for the primitive
style of the prints, but it was never used
again by Blumenthal at his Spiral Press.*

FIGURES OF THOLUS

Ye godly headless figures of Greece,
Though thy form is in part destroyed,
Is then thy breath of Athens' days ended?
And art thou scattered and strewn on the tide of time?
Speak, oh ye white shadows of the past,
With limbs and torsos draped in grace,
In serenity and nobility in the kingdom of art.
Oh lyrical, graceful, and excellent forms—
Static in place, and mobile in space,
Silenced and hidden wert thou,
But thou art, as thou hast always been.
Tholus,—
Though thy temples are in part destroyed,
And thy palaces and arenas down-worn by time,—
Space might have frozen about thy forms,
And left us the moulds thy past to rebuild,
And make us part of thee,—Tholus.
Speak thou silent mouths of Greece,
Move thy limbs and heads and torsos superb,
Let us see and here more of your all!
Stir, move, breathe,—

I had purchased a small, foot-operated press and a few hundred pounds of type and had begun work on a book of poems and woodcuts, both by the American painter, Max Weber. The woodcuts were fragile pieces of wood, $2 \times 4\frac{1}{2}$ inches, and only $\frac{1}{8}$ inch thick, Mr. Weber had kept from a few packages of honey, sold in those years in comb. He used a pocketknife, in the manner of Gauguin, cutting for depth and scraping for texture. These slivers of wood became exquisite primitive heads and figures, little compositions of great beauty. The poems, and electrotypes from the blocks, were finally printed in one color on our small press, and became the first book to bear The Spiral Press imprint.

– Joseph Blumenthal, *The Spiral Press Through Four Decades*. New York, The Pierpont Morgan Library, 1966.

7. Voltaire, CANDIDE

Random House, New York, 1928

Ink drawings (printed from line engravings)
by Rockwell Kent
(1882–1971).

1,470 copies: 95 copies hand-colored.

Designed by Elmer Adler and Rockwell Kent, set in Bernhard Modern type, printed on handmade paper by the Pynson Printers.

11 1/16 x 7 3/8 in.

Both the thin, sharp, Bernhard font and Rockwell Kent's line drawings were modern for their time, yet both speak of the 1920s to today's eyes. They match as closely as any in weight, and as if to emphasize the fact Adler uses a double line around the folios at the top of the page.

insensibility between life and death when I felt myself oppressed by something which moved on my body. I opened my eyes and saw a white man of good appearance who was sighing and muttering between his teeth: *O che sciagura d'essere senza coglioni!*

CONTINUATION OF THE OLD WOMAN'S MISFORTUNES

CHAPTER XII

AMAZED and delighted to hear my native language, and not less surprised at the words spoken by this man, I replied that there were greater misfortunes than that of which he complained. In a few words I informed him of the horrors I had undergone and then swooned again. He carried me to a neighbouring house, had me put to bed, gave me food, waited on me, consoled me, flattered me, told me he had never seen anyone so beautiful as I, and that he had never so much regretted that which no one could give back to him. 'I was born at Naples,' he said, 'and every year they make two or three thousand children there into capons; some die of it, others acquire voices more beautiful than women's, and others become the governors of States. This operation was performed upon me with very great success and I was a musician in the chapel of the Princess of Palestrina.' 'Of my mother,' I exclaimed. 'Of your mother!' cried he, weeping. 'What! Are you that young princess I brought up to the age of six and who even then gave promise of being as beautiful as you are?' 'I am! my mother is four hundred yards from here, cut into quarters under a heap of corpses . . .' I related all that had happened to me; he also told me his adventures and informed me how he had been sent to the King of Morocco by a Christian power to make a treaty with that monarch whereby he was supplied with powder, cannons and ships to help to exterminate the commerce of other Christians. 'My mission is accomplished,' said this honest

eunuch, 'I am about to embark at Ceuta and I will take you back to Italy. *Ma che sciagura d'essere senza coglioni!* I thanked him with tears of gratitude; and instead of taking me back to Italy he conducted me to Algiers and sold me to the Dey. I had scarcely been sold when the plague which had gone through Africa, Asia and Europe, broke out furiously in Algiers. You have seen earthquakes; but have you ever seen the plague?" "Never," replied the Baroness. "If you had," replied the old woman, "you would admit that it is much worse than an earthquake. It is very common in Africa; I caught it. Imagine the situation of a Pope's daughter aged fifteen, who in three months had undergone poverty and slavery, had been raped nearly every day, had seen her mother cut into four pieces, had undergone hunger and war, and was now dying of the plague in Algiers. However, I did not die; but my eunuch and the Dey and almost all the seraglio of Algiers perished. When the first ravages of this frightful plague were over, the Dey's slaves were sold. A merchant bought me and carried me to Tunis; he sold me to another merchant who re-sold me at Tripoli; from Tripoli I was re-sold to Alexandria, from Alexandria re-sold to Smyrna, from Smyrna to Constantinople. I was finally bought by an Aga of the Janizaries, who was soon ordered to defend Azov against the Russians who were besieging it. The Aga, who was a man of great gallantry, took his whole seraglio with him, and lodged us in a little fort on the Islands of Palus-Maeotis, guarded by two black eunuchs and twenty soldiers. He killed a prodigious number of Russians but they returned the compliment as well. Azov was given up

When Elmer Adler, Bennett Cerf, and Donald Klopfer established Random House in 1927, they invited Kent to illustrate their first book. He suggested Voltaire's Candide, and the three principals applauded the choice, recognizing in both Voltaire and Kent voices of modernity. Also, Kent had perfected the subtleties of body language so important to the art of caricature, with particular attention to traits, physiognomies, postures and reactions.... Over time, critics have lavished praise on the book and its original design. Monroe Wheeler, director of exhibitions and publications at the Museum of Modern Art, cited it as an exemplary union of printing, artist, and text, and a rare accomplishment that might be compared to the "Eclogæ et Georgica of Virgil that Maillol decorated for Count Kessler." The critic Carl Van Doren regarded the hand-colored volumes as the most beautiful of any edition of Candide since its original appearance in 1759.... Stanley Morison ... deemed Kent's Candide the most important illustrated book to have been made in America.

– Jake Milgram Wien, *Rockwell Kent: The Mythic and the Modern*. New York, Hudson Hills Press, 2005.

8. Samuel Taylor Coleridge, THE RIME OF THE ANCIENT MARINER

Douglas Cleverdon, London, 1929

Copper engravings
by David Jones
(1895–1974).

470 copies: 60 with an extra suite of
the engravings; 10 with an extra suite
and original drawing.

Designed by Stanley Morison, set in
Warde-Arrighi types, printed at the
Fanfare Press on paper handmade
specially for this edition by Barcham
Green.

12¼ x 9¾ in.

*David Jones was a deeply spiritual –
and deeply troubled – artist. His semi-
abstract etchings have a primal relation-
ship to Coleridge's text, dealing with the
agony and eventual holy reconciliation
of the Ancient Mariner. Morison's ele-
gant typography, in an early printing of
Frederic Warde's Arrighi type, suits both
the words and images.*

Like vessel,
like crew !

Her lips were red, her looks were free,
Her locks were yellow as gold :
Her skin was as white as leprosy,
The Night-Mair LIFE-IN-DEATH was she,
Who thicks man's blood with cold.

Death, and
Life-in-Death
have diced for
the ship's crew,
and she (the
latter) winneth
the ancient
Mariner.

The naked hulk alongside came,
And the twain were casting dice ;
'The game is done! I've, I've won!'
Quoth she, and whistles thrice.

No twilight
within the
courts of the Sun.

The Sun's rim dips; the stars rush out :
At one stride comes the dark ;
With far-heard whisper, o'er the sea,
Off shot the Spectre-bark.

We listen'd and look'd sideways up !
Fear at my heart, as at a cup,
My life-blood seem'd to sip !
The stars were dim, and thick the night,
The Steersman's face by his lamp gleam'd white ;
From the sails the dews did drip —

At the rising of
the Moon,

Till clombe above the eastern bar
The horned Moon, with one bright star
Within the nether tip.

12

In preparation for the ten engravings, . . . David made between 150 and 200 pencil drawings: all of which, alas, he destroyed except for ten that accompanied the ten special copies. He did not conceive them so much as simple illustrations, but rather as symbolic imagery drawn from the depths of Coleridge's creative imagination. . . . They are arguably David Jones' finest series. . . . Moreover, this was his last major work as an engraver.

– Douglas Cleverdon, *The Engravings of David Jones.* London, Clover Hill Editions, 1981.

9. William Shakespeare, HAMLET

The Cranach Press, Weimar, 1929

Woodcuts
by Edward Gordon Craig
(1872–1966).

255 copies: 17 on Japan paper with
suite, 8 on vellum with additional
suite of the prints (German edition)
and 322 copies (English edition); 15
on Japan with suite of proofs; 8 on
vellum with suite.

Layout by Count Harry Kessler and
the artist using a typeface designed
by Edward Johnston based on a
gothic font of Fust & Schoeffer.
Printed on the handpress at the
Cranach Press on a paper specially
made by Maillol.

13¼ x 9⅛ in.

Edward Gordon Craig first created these
black silhouette figures when he was
working on a stage production, after
which he adapted them as prints for this
volume. The archaic-looking font, based
on a typeface used at the dawn of print-
ing by Fust & Schoeffer, is heavy enough
to combine with the dark cuts, while
also alluding to the medieval origins of
Shakespeare's play.

DRITTER AKT
ZWEITE SZENE

von einem weibe auf veranlas-
sung seines onkels, der hoffte,
dadurch den prinzen zu fall zu
bringen, und so zu entdecken, ob
sein irrsinn gebeuchelt sei oder
nicht; und wie Hamblet durch
kein mittel dazu zu bringen
war, sich mit dem weibe abzu-
geben, und was darauf folgte.
Nachdem Gerutbe, wie ich schon
früher erzählt habe, sich so
weit vergessen hatte, erkannte
der prinz Hamblet, daß er in
lebensgefahr schwebe, da ihn
seine eigene mutter preisgab,
und alle ihn verließen, und daß
Fengo keine zeit verlieren werde,
ihn denselben weg geben zu las-
sen wie seinen vater Horwendil.
Um den hinterlistigen tyrannen
zu täuschen, der meinte, er sei
solchen geistes kind, daß er
nicht lange zögern werde, wenn
er erst einmal erwachsen sei,
den tod seines vaters zu rächen,
beschloss er daher, den verrückten
mit solch schlauen und feinen
handlungen zu spielen, daß es
so aussähe, als ob er völlig den
verstand verloren habe. Also
hinter solchem schleier verbarg er
sein vorhaben und verteidigte
sein leben vor dem verrat und
den anschlägen des tyrannen,
seines onkels. Und als ob er bei
dem römischen prinzen, der,
weil er so tat, als sei er ein narr,
Brutus genannt wurde, in die
schule gegangen wäre, befolgte

DIE TRAGISCHE GESCHICHTE VON

Dem zweiten die umarmung zu gestatten.
König (im schauspiel)
　　Ich glaub, ihr denket jetzt, was ihr gesprochen,
　　Doch ein entschluß wird oft von uns gebrochen.
　　Der vorsatz ist ja der erinnrung knecht,
　　Stark von geburt, doch bald durch zeit geschwächt
　　Wie herbe früchte fest am baume hangen,
　　Doch leicht sich lösen, wenn sie reif erlangen.
　　Notwendig ist's, daß jeder leicht vergißt
　　Zu zahlen, was er selbst sich schuldig ist.
　　Wo leidenschaft den vorsatz hingewendet,
　　Entgeht das ziel uns, wann sie selber endet.
　　Das ungestüm sowohl von freud und leid
　　Zerstört mit sich die eigne wirksamkeit.
　　Laut klagt das leid, wo laut die freude schwärmet,
　　Leid freut sich leicht, wenn freude leicht sich härmet.
　　Die welt vergeht: es ist nicht wunderbar,
　　Daß mit dem glück selbst liebe wandelbar.
　　Denn eine frag ist's, die zu lösen bliebe,
　　Ob lieb das glück führt, oder glück die liebe.
　　Der große stürzt, seht seinen günstling fliehn.
　　Der arme steigt, und feinde lieben ihn.
　　So weit scheint liebe nach dem glück zu wählen:
　　Wer ihn nicht braucht, dem wird ein freund nicht
　　feblen,
　　Und wer in not versucht den falschen freund,

96

40

One evening in 1905 ... [Craig] became absorbed by a concept of drama without script or voice; the elements would be form, light, movement, and perhaps music. For this ideal drama he made a series of constructionist etchings; and in the same year he met Isadora Duncan whose dancing matched his thought very closely. The production upon which he was working, and experimenting with some of his theories, though it certainly had a script, was Stanislavsky's Hamlet. He designed screens and moved them about his own model stage, experimenting with abstract forms and light. He also cut little figures in plywood, to move among the screens, and one day idly inking one of them he printed it flat and black; so were born his "black figures" which we see in the Cranach Press Hamlet.

– Colin Franklin, *Fond of Printing, Gordon Craig as Typographer and Illustrator*. New York, The Typophiles, 1980.

41

10. Edgar Allan Poe,
THE FALL OF THE HOUSE OF USHER

Halcyon Press [A. A. M. Stols], Maastricht, 1930

Aquatints
by Alexandre Alexeïeff
(1901–1982).

365 copies: 10 on antique Japan vellum, 30 on Imperial Japan paper.

Typography by Jan van Krimpen, set in Fleischmann types, printed at Johann Enschedé en Zonen, Haarlem.

7⅝ x 9⅞ in.

Aquatint is a labor-intensive print medium, which may be why it is rare compared to etching, lithography, and other printing techniques used by artists. The eighteenth-century Fleischmann font, for which the original punches are held by the ancient Enschedé Typefoundry in the Netherlands, is also quite uncommon.

V.

But evil things, in robes of sorrow,
Assailed the monarch's high estate;
(Ah, let us mourn, for never morrow
Shall dawn upon him, desolate!)
And, round about his home, the glory
That blushed and bloomed
Is but a dim-remembered story
Of the old time entombed.

VI.

And travellers now within that valley,
Through the red-litten windows, see
Vast forms that move fantastically
To a discordant melody;
While, like a rapid ghastly river
Through the pale door,
A hideous throng rush out for ever,
And laugh — but smile no more.

40

42

The ten somewhat disturbing, surreal aquatints made by Alexeïeff for this book perfectly complement Poe's macabre story about a woman being buried alive. The soft gradations of tone, monochromatic and mainly dark, create a mood of night and fog that evokes the sinister feeling of Poe's words.

The Dutch publisher Alexandre A. M. Stols (1900–1973) issued many bibliophile editions under several imprints. With most of his Halcyon Press books he employed the superlative Dutch type and book designer Jan van Krimpen to handle the book design. For the typography of this edition Van Krimpen did not use one of his own elegant typeface designs; instead he selected a somewhat crude, spiky typeface cut by J. M. Fleischmann in 1739. Like the aquatint prints, the typeface adds to the uneasy mood of the volume; there is a harmonious combination of text, art, and typography. The aquatints themselves are carefully printed on the soft Pannekoek paper so the impression of the plate edges hardly shows on the back of the pages, thereby not interfering with the printed text. And, of course, the book is bound in black cloth.

– Jerry Kelly

43

11. Mary Austin, TAOS PUEBLO

Privately printed for Ansel Adams, San Francisco, 1930

Photographs
by Ansel Adams
(1902–1984).

108 copies.

Designed by Edwin Grabhorn,
with decorations by Valenti Angelo.
Printed by a trade printer under the
direction of the Grabhorn Press
from handset Goudy Newstyle type.

16¾ x 12½ in.

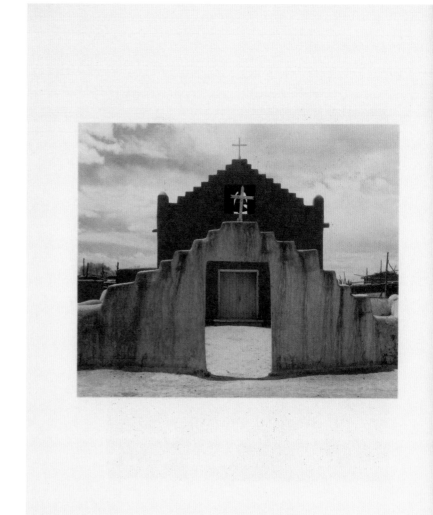

*This classic photography book was
Ansel Adams's first publication. For
the printing he chose the Grabhorn
Press, which was then just a few years
old, but would go on to become the
most celebrated of many Californian
fine presses.*

44

TAOS PUEBLO

PHOTOGRAPHED BY ANSEL EASTON ADAMS

AND DESCRIBED BY MARY AUSTIN

SAN FRANCISCO

MCMXXX

*

The printing of this book presented quite a problem, says Edwin Grabhorn in a masterpiece of understatement. The page size was so large that only one page could be printed at a time. The paper used was a special make and was supplied only on rolls, with the result that each sheet curled and hence the center space was never quite straight. Then the binder refused to accept the job; and so the type was reset, and sent to a trade pressroom to be printed on a larger press.

– Elinor Raas Heller and David Magee, *Bibliography of the Grabhorn Press: 1915–1940.* San Francisco, Grabhorn Press, 1940.

12. [The Holy Bible], CANTICUM CANTICORUM SALOMONIS

The Cranach Press, Weimar, 1930

Wood engravings
by Eric Gill
(1882–1940).

158 copies: 50 on Japan paper and 8
on vellum (English edition); 158 copies,
50 on Japan paper and 8 on vellum
(German edition); 268 copies, 60 on
Japan paper and 8 on vellum (Latin
edition); 158 copies, 50 on Japan paper
and 8 on vellum (French edition).

Designed by Count Harry Kessler,
printed on Maillol-Kessler handmade
paper from Cranach Jenson and
Tagliente types.

10 x 5¼ in.

CANTICUM CANTICORUM

Quam pulchrae sunt mammae tuae,
soror mea, sponsa!
Pulchriora sunt ubera tua vino,
et odor unguentorum tuorum
super omnia aromata.
Favus distillans labia tua, sponsa;
mel et lac sub lingua tua;
et odor vestimentorum tuorum
sicut odor thuris.
Hortus conclusus soror mea, sponsa,
hortus conclusus, fons signatus.
Emissiones tuae
paradisus malorum punicorum,
cum pomorum fructibus,
cypri cum nardo.
Nardus et crocus,
fistula et cinnamomum,
cum universis lignis Libani;
myrrha et aloe,
cum omnibus primis unguentis.
Fons hortorum,
puteus aquarum viventium,
quae fluunt impetu de Libano.
Surge, aquilo; et veni, auster;
perfla hortum meum, et fluant
aromata illius.

16

The three books from Kessler's Cranach Press in this selection could hardly be more different in style (cf. nos. 4 and 9), yet each contains carefully coordinated art, text, format, and printing.

46

17

It must have astounded Kessler to encounter in Gill a modern individual who had the desire to confront in both art and life his own theory that Christianity had undermined the erotic and the sensual and had therefore hindered the growth of a new culture. For here was Eric Gill, in stark contrast, seeking to live out the idea of combining this very religion with sensuality and, what is more, an erotic sensuality. The unique godliness of Eric Gill must have re-minded Kessler in 1925 of his ideas on the mystics, and perhaps made him think that the concept of sensuality, which originally sprang from the mys-tics, had waited patiently for Gill's own attempt to set down, with acute sen-suality, his godliness in a design of the Song of Songs *for the Cranach Press.*

– John Dieter Brinks, in *The Book as a Work of Art: The Cranach Press of Count Harry Kessler.* Laubach and Berlin, Triton Verlag, and Williamstown, MA, Williams College, 2005.

13. Ovid (*trans.* George Lafaye), LES MÉTAMORPHOSES

Albert Skira, Lausanne, 1931

Etchings
by Pablo Picasso
(1881–1973).

145 copies: 25 on Japan paper with a
supplementary suite of the prints; 5
on Japan paper with 2 extra suites, 120
on Arches paper.

Plates printed by Louis Fort; text print-
ed from Caslon type by Léon Pichon.

12¹³⁄₁₆ x 10¼ in.

*The exquisite idealized contours of
Picasso's etchings in this book are some
of the best examples of his classical
style. Accordingly, the typography
for this edition of Ovid's ancient text
is set in a classic font (Caslon) using
traditional typography, with large
drop caps printed in red, and generous
margins for both text and images.*

MAIS les hauteurs de l'éther ne devaient pas être un asile plus sûr que la terre : car les Géants, à ce qu'on assure, voulurent conquérir le royaume des cieux et entassèrent, pour s'élever jusqu'aux astres, montagnes sur montagnes. Alors le père tout-puissant fracassa l'Olympe sous les traits de la foudre et fit crouler le Pélion à bas de l'Ossa, qui le soutenait. Comme les corps de ces combattants barbares gisaient ensevelis sous une telle masse, leur ouvrage, la Terre, sur qui avait abondamment coulé le sang de ses enfants, en fut, dit-on, imbibée ; elle anima ses flots encore chauds et elle en forma, pour ne pas voir finir les derniers rejetons de sa race, d'autres êtres à face humaine. Mais cette race méprisa les dieux ; elle fut, entre toutes, avide des horreurs du carnage et ne respira que la violence ; on reconnaissait qu'elle avait été créée avec du sang.

LORSQUE le père des hommes, fils de Saturne, a vu ce spectacle du haut des cieux, il gémit et, se rappelant un crime trop récent encore pour avoir été divulgué, l'horrible festin servi à la table de Lycaon, il en conçoit au fond du cœur un courroux terrible, digne de Jupiter ; il convoque le conseil des dieux ; sans retard, ils accourent à son appel. Il est dans l'empyrée une voie que l'on distingue aisément par un ciel serein ; elle porte le nom de Voie lactée ; sa blancheur éclatante la signale à tous les yeux. C'est par là que les dieux d'en haut se rendent à la demeure royale où réside le souverain maître du tonnerre. A droite et à gauche s'étendent, portes ouvertes, les atriums hantés par la noblesse céleste ; la plèbe habite à part, dans d'autres lieux ; sur le devant et sur les côtés, les dieux puissants ont établi leurs pénates. Tel est le séjour que j'oserai appeler, si on me permet un langage si audacieux, le Palatin du ciel. Donc, lorsque les dieux furent entrés dans ce sanctuaire resplendissant de marbre, Jupiter, lui-même assis sur un trône plus élevé et s'appuyant sur un sceptre d'ivoire, agita trois ou quatre fois autour de sa tête sa redoutable chevelure, qui ébranla la terre, la mer et les astres. Puis il exhala en ces termes son indignation : « Non, je n'ai pas été plus alarmé pour l'empire que j'exerce sur le monde, au temps où les monstres anguipèdes se préparaient à enlacer de leurs cent bras le ciel captif. Sans doute l'ennemi était redoutable, mais cette guerre ne pouvait

12

48

[Picasso's art] reached its culmination in the etchings to Ovid's Metamor- phoses, *in which purity of line, the economy of detail and the balance of the composition approach the limits of perfection.*

– Wilhelm Boeck, *Picasso.* New York, Harry N. Abrams, 1955.

14. [The Holy Bible], THE FOUR GOSPELS

Golden Cockerel Press, Waltham St. Lawrence, 1931

Wood engravings
by Eric Gill
(1882–1940).

500 copies: 12 on vellum.

Designed by
Eric Gill and Robert Gibbings,
printed from Gill's Golden Cockerel
type at the Golden Cockerel Press on
Batchelor handmade paper.

13⅛ x 9¼ in.

As John Dreyfus points out, this edition of The Four Gospels *with wood-engravings by Eric Gill is one of the masterpieces of twentieth-century book-making. Gill's designs often entwine letters, in the manner of illuminated manuscripts. The Golden Cockerel font was also designed by Gill, who devised the layouts with Robert Gibbings, proprietor of the press.*

heard them laid them up in their hearts, saying, What man-
ner of child shall this be! And the hand of the Lord was
with him. ✳ And his father Zacharias was filled with the
Holy Ghost, and prophesied, saying,

BLESSED BE THE LORD GOD OF ISRAEL;
For he hath visited and redeemed his people,
And hath raised up an horn of salvation for us
In the house of his servant David;
As he spake by the mouth of his holy prophets, which
 have been since the world began:
That we should be saved from our enemies, and from
 the hand of all that hate us;
To perform the mercy promised to our fathers,
And to remember his holy covenant;
The oath which he sware to our father Abraham,
That he would grant unto us, that we being delivered
 out of the hand of our enemies
Might serve him without fear,
In holiness and righteousness before him, all the days
 of our life.
And thou, child, shalt be called the prophet of the Highest:
For thou shalt go before the face of the Lord to prepare
 his ways;
To give knowledge of salvation unto his people
By the remission of their sins,
Through the tender mercy of our God;
Whereby the dayspring from on high hath visited us,
To give light to them that sit in darkness and in the
 shadow of death,
To guide our feet into the way of peace.
And the child grew, and waxed strong in spirit, and was in
the deserts till the day of his shewing unto Israel.

136

50

IT CAME TO PASS IN
THOSE DAYS, THAT
THERE WENT OUT A DECREE
FROM CÆSAR AUGUSTUS, THAT ALL THE WORLD
SHOULD BE TAXED. (AND THIS TAXING WAS FIRST
made when Cyrenius was governor of Syria.) And all went to
be taxed, every one into his own city. And Joseph also went
up from Galilee, out of the city of Nazareth, into Judæa,
unto the city of David, which is called Bethlehem; (because
he was of the house and lineage of David:) To be taxed with
Mary his espoused wife, being great with child. And so it
was, that, while they were there, the days were accomplished
that she should be delivered. And she brought forth her

137

Gill's experience of decorating and illustrating books . . . gave him plenty of opportunity to develop his talents as a wood-engraver, so that he was well equipped to engrave a great quantity of illustrations for books printed by the Golden Cockerel Press between 1925 and 1938, including a magnificent edition of The Four Gospels *(1931) – a work which I regard as his greatest achievement as an illustrator and one of the most brilliantly planned and beautifully executed books of the twentieth century.*

– John Dreyfus, introduction to *The Eric Gill Collection of the Humanities Research Center*. Austin, The University of Texas, 1982.

15. Ambroise Vollard, RÉINCARNATIONS DU PÈRE UBU

Ambroise Vollard, Paris, 1932

Etchings
by Georges Rouault
(1871–1958),
along with reproductions of his
drawings engraved on wood by
Georges Aubert.

335 copies: 30 on Van Gelder paper
with an extra suite of the etchings,
55 special copies on Montvale paper
with the prints on Arches and Rive
papers; 250 on Vidalon paper.

Etchings printed by Henri Jourde,
wood engravings and text set in Plan-
tin type printed by Aux Deux Ours.

17¼ x 13¼ in.

tiole empaillée comme celle que nous rapportâmes d'une
exploration faite naguère à l'Office des colonies et que
nous dénommâmes « expédition coloniale ».

LE PRÉSIDENT DE LA S.D.N. — Qu'est-ce donc,
Père Ubu, qu'une expédition coloniale ?

LE PÈRE UBU. — Une expédition coloniale, d'abord,
s'effectue par le moyen d'une grande maison flottante, la
Maison-Bateau, où nous accédâmes en nous élançant dans
les airs par le truchement d'un appareil inventé par nous,
l'appareil grue. Laquelle chose grue est aussi très utile
pour embarquer l'alcool comme en témoigne l'hymne des
matelots à la grue :

> Oh ! hisse-nous, barriques, barriques,
> Oh ! hisse-nous, barriques tafia.

Mais d'abord, connaissez-vous la chose Bateau, mon-
sieur le Président de la Société des Nations ?

LE PRÉSIDENT DE LA S.D.N. *(Il tire de sa poche
un petit bateau.)* — Certes, je connais « Bateau » et
j'en possède même ce fort mignon avec lequel je gagne
la course sur le bassin d'essai de la Société des Nations.

LE PÈRE UBU. — Le nôtre de bateau était haut à
l'instar d'une montagne... Mais ce qui nous frappa le plus,
ce fut un plat de viande fort excellent, que l'on mange dans
Bateau et qui s'appelle Agneau... Au temps où nous étions
capitaine de dragons, officier d'ordonnance de Venceslas
et ancien roi d'Aragon, nous mangions de la soupe polo-
naise, des côtes de rastron, du veau, du poulet, du pâté
de chien, des croupions de dinde, de la charlotte russe,

32

*The "Plantin" font used for this book
(no relation to Monotype Plantin) is a
bit heavy and slightly crude, making it
a good match for Rouault's bold, dark
images.*

52

Père Ubu emerged for Vollard as a kind of alter ego, one from which he never parted. In 1932 he brought forth a more massive and ambitious volume, Réincarnations du Père Ubu, *with illustrations by Georges Rouault. The artist had completed the plates during 1916–28, but Vollard, as usual, did not publish the book until several years later. His own conception and Rouault's heroic-comic symbols have much in common. Yet Georges Rouault lifted the Vollard character, as it happened, to the plane of somber and disturbing drama.*

– Una E. Johnson, *Ambroise Vollard, Editeur.* New York, The Museum of Modern Art, 1977.

16. Stéphane Mallarmé, POÉSIES

Albert Skira, Lausanne, 1932

Etchings
by Henri Matisse
(1869–1954).

145 copies: 5 on Imperial Japan paper
with two suites of the prints, 25 with
one suite on Arches paper, 95 on
Arches paper.

Designed by Matisse, etchings printed
by Atelier Lacourière, text printed
from "Garamond" (Jannon) italic type
by Léon Pichon.

$12^{15}/_{16}$ x $9^{13}/_{16}$ in.

APPARITION

*La lune s'attristait. Des séraphins en pleurs
Rêvant, l'archet aux doigts, dans le calme des fleurs
Vaporeuses, tiraient de mourantes violes
De blancs sanglots glissant sur l'azur des corolles
— C'était le jour béni de ton premier baiser.
Ma songerie aimant à me martyriser
S'enivrait savamment du parfum de tristesse
Que même sans regret & sans déboire laisse
La cueillaison d'un Rêve au cœur qui l'a cueilli.
J'errais donc, l'œil rivé sur le pavé vieilli
Quand avec du soleil aux cheveux, dans la rue
Et dans le soir, tu m'es en riant apparue
Et j'ai cru voir la fée au chapeau de clarté
Qui jadis sur mes beaux sommeils d'enfant gâté
Passait, laissant toujours de ses mains mal fermées
Neiger de blancs bouquets d'étoiles parfumées.*

14

*Matisse took an active interest in the
design of his books. For this edition of
Mallarmé's poetry, highlighted by the
artist's graceful, light etchings with
their sinuous line, a classic cursive type-
face, such as Jean Jannon's version of
Garamond italic used here, is perfectly
compatible.*

54

Matisse describes his approach to this, his first book (with original plates): "Etchings with a regular outline, very slender, without shading, which leave the page almost as white as before the printed impression. The design fills the unmargined page, for the design is not, as usual, massed toward the center, but radiating over the whole sheet. The rectos carrying the plates are placed opposite the versos bearing the text." . . . In etching these delicate lines, the artist used with considerable force a blunt sapphire point needle, which raised ridges in the copper and required very careful inking and wiping to retain the clarity of line.

– Eleanor Garvey, *The Artist & the Book, 1860–1960.* Cambridge, Harvard College Library, and Boston, Museum of Fine Arts, 1961.

17. Comte de Lautréamont, LES CHANTS DE MALDOROR

Albert Skira, Paris, 1934

Etchings
by Salvador Dalí
(1904–1989).

210 copies; 40 with an extra suite of
the etchings (but fewer were issued).

Etchings printed by Roger Lacourière,
text set in Garamond type printed by
Philippe Gonin on Arches wove paper.

12¹³⁄₁₆ x 10 in.

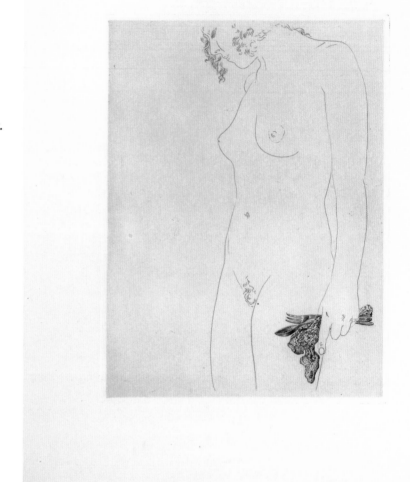

*An early work by Dalí, displaying
his thorough mastery of anatomy in
the academic tradition. The surrealist
etchings contained in this book explore
many of the themes that would later
appear repeatedly in Dalí's paintings
and graphic art.*

COMTE DE LAUTRÉAMONT

LES
CHANTS DE MALDOROR

Eaux-fortes originales de
SALVADOR DALI

PARIS
ALBERT SKIRA, ÉDITEUR
MCMXXXIV

It was Pablo Picasso who proposed that Lautréamont's inspiring 'cult' book should be illustrated by his compatriot Dalí, who has been introduced to it by the writer René Crevel. Dalí embarked on the task in 1932, drawing preliminary studies for some of the illustrations. He was approximately 28 years old when he made the series, about the same age as the 19th-century author of the bizarre texts who died so young. Dalí deployed the entire arsenal of his characteristic imagery in his illustrations to Les Chants. The etcher's tool transformed the poet's satanic deluge of words into a paradigm of the artist's own 'critical-paranoid' method. In the like-minded artist, Les Chants evoked associations, hallucinations and deliriums which are linked with his 'personal myths'. For example, Dalí quoted Jean-François Millet's popular painting The Angelus here for the first time. The well-known figures of the farmer and his wife sunk in prayer, standing in a potato field, appear in four etchings with items from Dalí's typical vocabulary, such as flaccid parts of the body supported by crutches and distorted bones.

– Grapheion: European Review of Modern Prints, Books and Paper, first issue, 2000.

18. Paul Éluard, FACILE

Éditions G.L.M., Paris, 1935

Reproductions, printed by
photogravure, of photographs
by Man Ray
(1890–1976).

1,225 copies: 20 on Japan paper;
25 with an original photograph.

Photogravures printed by Breger,
text printed from Bodoni type by the
publisher.

9⁹⁄₁₆ x 7¹⁄₁₆ in.

Au loin les fleurs fanées des vacances d'autrui
Un rien de paysage suffisant
Les prisons de la liberté s'effacent
Nous avons à jamais
Laissé derrière nous l'espoir qui se consume
Dans une ville pétrie de chair et de misère
De tyrannie

La paupière du soleil s'abaisse sur ton visage
Un rideau doux comme ta peau
Une aile salubre une végétation
Plus transparente que la lune du matin

Nos baisers et nos mains au niveau de nous-mêmes
Tout au delà ruiné
La jeunesse en amande se dénude et rêve
L'herbe se relève en sourdine
Sur d'innocentes nappes de petite terre

Premier dernière ardoise et craie
Fer et rouille seul à seule
Enlacés au rayon debout
Qui va comme un aveu
Ecorce et source redressée
L'un à l'autre dans le présent
Toute brume chassée
Deux autour de leur ardeur
Joints par des lieues et des années

Notre ombre n'éteint pas le feu
Nous nous perpétuons.

Facile *is an early example of the use of
photography in a* livre d'artiste. *The
shots of a woman's body (the author's
wife) are handled in a fresh way, with
photographs across spreads, vignetted
on the background paper, handled
almost as abstract imagery. The text
is carefully arranged to relate to the
silhouette of the figure.*

II

Au-dessous des sommets
Nos yeux ferment les fenêtres
Nous ne craignons pas la paix de l'hiver

Les quatre murs éteints par notre intimité
Quatre murs sur la terre
Le plancher le plafond
Sont des cibles faciles et rompues
A ton image alerte que j'ai dispersée
Et qui m'est toujours revenue

Un monotone abri
Un décor de partout

Mais c'est ici qu'en ce moment
Commencent et finissent nos voyages
Les meilleures folies
C'est ici que nous défendons notre vie
Que nous cherchons le monde

Un pic écervelé aux nuages fuyants au sourire éternel
Dans leurs cages les lacs au fond des trous la pluie
Le vent sa longue langue et les anneaux de la fraîcheur
La verdure et la chair des femmes au printemps
La plus belle est un baume elle incline au repos
Dans des jardins tout neufs amortis d'ombres tendres
Leur mère est une feuille
Luisante et nue comme une linge mouillé

Although Man Ray participated in and produced hundreds of fruitful collaborative works in his life, Façile must be ranked among the most successful. The book combines Paul Éluard's love poems to his wife Nusch with Man Ray's photographs of her in an extremely elegant design, integrating Man Ray's solarized, superimposed, double-exposed, and negative images into the page spreads in a way that makes image and text appear to intimately embrace. It is a fluent but not at all facile collaboration between the poet, the photographer, the model and muse, and the publisher, Guy Levis-Mano.

– David Levi Strauss, in *The Book of 101 Books*. New York, PPP Editions, 2001.

19. Henry David Thoreau, WALDEN

The Limited Editions Club, New York, 1936

Reproductions, printed by collotype,
of photographs
by Edward Steichen
(1879–1973).

1,500 copies.

Designed by Daniel Berkeley Updike
and printed from Scotch type at the
Merrymount Press. Photographs
printed by collotype by the Heliotype
Company.

9¾ x 7 in.

Following in the footsteps of the None-such Press (see no. 3), the Limited Editions Club was founded to produce high-quality books at relatively low prices for a large audience. The Club accomplished this by using machine-printers and fine mould-made papers, as opposed to costlier hand printing and handmade papers. Thus, the publishers could produce a book with work by one of the century's greatest photographers, printed by one of the century's greatest printers, at a low price for their 1,500 subscribers, even at the depth of the Depression.

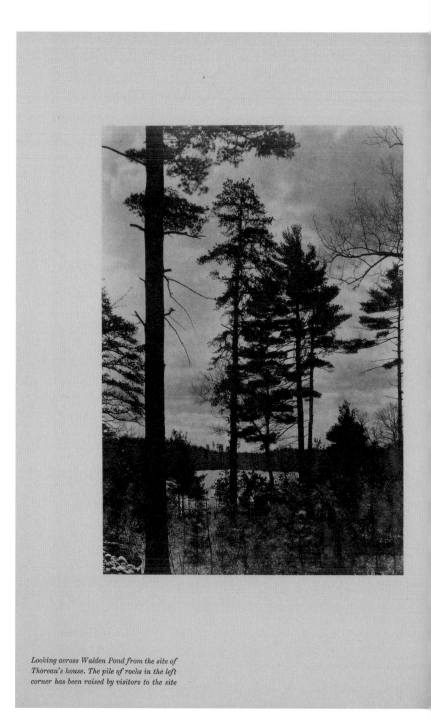

Looking across Walden Pond from the site of Thoreau's house. The pile of rocks in the left corner has been raised by visitors to the site

WALDEN

OR LIFE IN THE WOODS

I

Economy

WHEN I wrote the following pages, or rather the bulk of them, I lived alone, in the woods, a mile from any neighbor, in a house which I had built myself, on the shore of Walden Pond, in Concord, Massachusetts, and earned my living by the labor of my hands only. I lived there two years and two months. At present I am a sojourner in civilized life again.

I should not obtrude my affairs so much on the notice of my readers if very particular inquiries had not been made by my townsmen concerning my mode of life, which some would call impertinent, though they do not appear to me at all impertinent, but, considering the circumstances, very natural and pertinent. Some have asked what I got to eat; if I did not feel lonesome; if I was not afraid; and the like. Others have been curious to learn what portion of my income I devoted to charitable purposes; and some, who have large families, how many poor children I maintained. I will therefore ask those of my readers who feel no particular interest in me to pardon me if I undertake to answer some of these questions in this book. In most books, the *I*, or first person, is omitted; in this it will be retained; that, in respect to egotism, is the main difference. We commonly do not remember that it is, after all, always the first person that is speaking. I should not talk so much about myself if there were anybody else whom I knew as well. Unfortunately, I am confined to this theme by the narrowness of my experience. Moreover, I, on my side, require of every writer, first or last, a simple and sincere account of his own life, and not merely what he has heard of other men's lives; some such ac-

The exquisitely photographed pond in Walden is by no means Steichen's most valuable. That record belongs to his almost unique, three-color gum-bichromate print of The Pond—Moonlight, Mamaroneck, 1904, *sold for $2.9 million at Sotheby's in 2008. Indeed, the collotype illustrations in Thoreau's classic differ dramatically from Steichen's earlier, Photo-Secession-style photograph—yet they are still identifiably "modern" nature studies by the nationally known art photographer. The gelatin-based collotype process used to print the book's sixteen photographs avoids the dot pattern inevitable even in the finest screen reproduction. In the impeccable presswork, both close-tone gray clouds and thread-thin black branches are equally and subtly visible. Whether through long shots or close-ups, the artist intensifies understanding of photographic seeing. Though the Mamaroneck pond was purposely soft-focus and late Symbolist, and the Walden views are as crisp as studies by Paul Strand and Ansel Adams, all these hymns by Steichen to untouched Nature are displays of camera and printing mastery as well as intimate yet transcendental meditations. Together, his early and later landscapes suggest how his fin-de-siècle aesthetics survived in his modernism of the 1930s.*

– Anne H. Hoy

20. Sinclair Lewis, MAIN STREET

The Limited Editions Club, New York, 1937

Reproductions of color drawings
by Grant Wood
(1891–1942).

1,500 copies.

Designed by William Kittredge and
printed from Caslon type at the
Lakeside Press on Arak paper.

9¾ x 7½ in.

162 "But, dear, the trouble with that film—it wasn't that it got in so many legs, but that it giggled coyly and promised to show more of them, and then didn't keep the promise. It was Peeping Tom's idea of humor."

"I don't get you. Look here now——"

She lay awake, while he rumbled with sleep.

"I must go on. My 'crank ideas,' he calls them. I thought that adoring him, watching him operate, would be enough. It isn't. Not after the first thrill.

"I don't want to hurt him. But I must go on.

"It isn't enough, to stand by while he fills an automobile radiator and chucks me bits of information.

"If I stood by and admired him long enough, I would be content. I would become a 'nice little woman.' The Village Virus. Already—— I'm not reading anything. I haven't touched the piano for a week. I'm letting the days drown in worship of 'a good deal, ten plunks more per acre.' I won't! I won't succumb!

"How! I've failed at everything: the Thanatopsis, parties, pioneers, city hall, Guy and Vida. But—— It doesn't *matter!* I'm not trying to 'reform the town' now. I'm not trying to organize Browning Clubs, and sit in clean white kids yearning up at lecturers with ribbony eyeglasses. I am trying to save my soul.

"Will Kennicott, asleep there, trusting me, thinking he holds me. And I'm leaving him. All of me left him when he laughed at me. It wasn't enough for him that I admired him; I must change myself and grow like him. He takes advantage. No more. It's finished. I will go on."

IV

HER violin lay on top of the upright piano. She picked it up. Since she had last touched it the dried strings had snapped, and upon it lay a gold and crimson cigar-band.

V

SHE longed to see Guy Pollock, for the confirming of the brethren in the faith. But Kennicott's dominance was heavy upon her. She could not determine whether she was checked by fear of him, or by inertia—by dislike of the emotional labor of the "scenes" which would be involved in asserting independence. She was like the revolutionist at fifty: not afraid of death, but bored by the probability of bad steaks and bad breaths and sitting up all night on windy barricades.

The second evening after the movies she impulsively summoned Vida Sherwin and Guy to the house for pop-corn and cider. In the living-room Vida and Kennicott debated "the value of manual training in grades below the eighth," while Carol sat beside Guy at the dining table, buttering pop-corn. She was quickened by the speculation in his eyes. She murmured:

Another Limited Editions Club volume with work by a major artist (Grant Wood, famous for his painting American Gothic) in a special edition (printed at the fine book department of The Lakeside Press in Chicago), produced to exceptional standards.

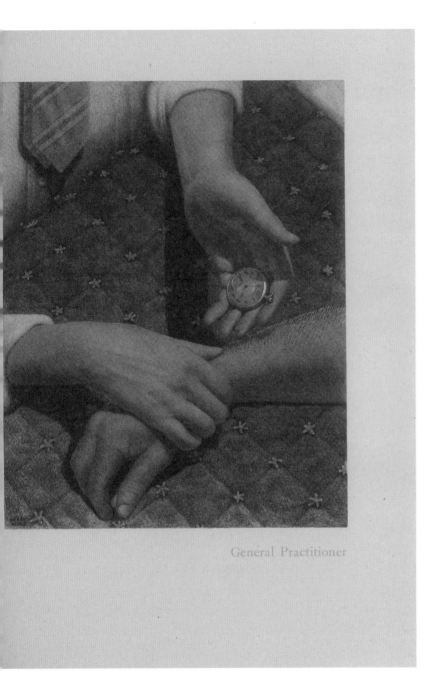

General Practitioner

A gentleman living somewhere in Iowa wrote me, to plant in my mind the idea that Grant Wood should be persuaded to illustrate Main Street. I thought it a good idea. . . . He should be proud, for Grant Wood's illustrations for Main Street *have exactly the right searingly photographic content, and Mr. Kittredge has surrounded them with an appropriately homely dress.*

–George Macy (publisher, The Limited Editions Club), *Quarto-Millenary*. New York, The Limited Editions Club, 1959.

21. W. Somerset Maugham, OF HUMAN BONDAGE

The Limited Editions Club, New York, 1938

Etchings
by John Sloan
(1871–1951).

1,500 copies.

Designed by Carl Purington Rollins,
set in Bembo type, printed at the Yale
University Press.

9 x 6 in.

*The Limited Editions Club did not seek
uniformity in their publications, far
from it: this book contains intaglio
prints by John Sloan, while the Grant
Wood volume (no. 20) had color prints,
and the Steichen (no. 19) collotype
prints of photographs. All use different
designers, fonts, printers, and paper.
Instead of conformity, variety in all
aspects of the art and bookmaking was
the guiding principle.*

Of Human Bondage

always did when she was caught in a lie; then the flash of anger which he knew so well came into her eyes as she instinctively sought to defend herself by abuse. But she did not say the words which were on the tip of her tongue.

"Oh, I was only going to see the show. It gives me the hump sitting every night by myself."

He did not pretend to believe her.

"You mustn't. Good heavens, I've told you fifty times how dangerous it is. You must stop this sort of thing at once."

"Oh, hold your jaw," she cried roughly. "How d'you suppose I'm going to live?"

He took hold of her arm and without thinking what he was doing tried to drag her away.

"For God's sake come along. Let me take you home. You don't know what you're doing. It's criminal."

"What do I care? Let them take their chance. Men haven't been so good to me that I need bother my head about them."

She pushed him away and walking up to the box-office put down her money. Philip had threepence in his pocket. He could not follow. He turned away and walked slowly down Oxford Street.

"I can't do anything more," he said to himself.

That was the end. He did not see her again.

IIO

CHRISTMAS that year falling on Thursday, the shop was to close for four days: Philip wrote to his uncle asking whether it would be convenient for him to spend the holidays at the vicarage. He received an answer from Mrs. Foster, saying that Mr. Carey was not well enough to write himself, but wished to see his nephew and would be glad if he came down. She

718

. . . at the corner of Oxford Street she . . . crossed over to a music-hall.

Almost exact contemporaries, the Ashcan School artist John Sloan and the authors W. Somerset Maugham (1874–1965) and Theodore Dreiser (1871–1945), who wrote the foreword for this edition, all came of age before World War I and created their best-known works about that era's youth caught by harsh social forces and their own passions. Dreiser had praised Of Human Bondage when Maugham's lightly-veiled autobiography first appeared in 1915. Sloan, a Socialist since his days of political cartooning for The Masses (1912–16), here dramatizes turning points in the plot and charged moments for the characters with his heavily crosshatched etchings. This city scene illustrates the last time Philip saw Mildred (Bette Davis in the best-known film of the novel): the altruistic doctor, her former lover, lacks the money to prevent her returning to streetwalking. This two-volume boxed set, the second illustrated version of the book, reflects the British author's popularity and wealth, at their peaks in the 1930s, and the resonance of his story during the Great Depression. Sloan's sixteen etchings extend the figurative style for which New York's first advanced artists' group of the 1900s was known.

– Anne H. Hoy

22. Marco Polo, IL MILIONE

Ulrico Hoepli, Milan, 1942

Lithographs
by Massimo Campigli
(1895–1971).

150 copies: 10 with an extra suite of
the prints on Japan paper.

Designed by Giovanni Mardersteig,
printed from Griffo type at the
Officina Bodoni on Fabriano paper,
lithographs printed by Pietro
Fornasetti.

16¼ x 11½ in.

*Giovanni Mardersteig is considered by
many experts to be the finest printer
of the twentieth century. He designed
numerous books with original graph-
ics created by assorted artists in various
media, including etching, woodcut (see
no. 25), and lithography, as here. All are
carefully arranged and meticulously
printed, in this case using Mardersteig's
own version of the Aldine font, named
Griffo after Aldus's punch cutter.*

XC
Della grande città del Giogui.

Quando l'uomo si parte da questo ponte, l'uomo va trenta miglia per ponente, tut-tavia trovando belle case e begli alberghi, e àlbori e vigne; e quivi truova una città che ha nome Giogui, grande e bella. Quivi hae molte badie d'idoli. Egli vivono di mer-catanzia e d'arti; quivi si lavora drappi di seta e d'oro e bel zendado, e quivi ha begli alberghi. Quando l'uomo hae passata questa villa d'uno miglio, l'uomo truova due vie: l'una va verso ponente, e l'altra va verso iscirocco. Quella di verso il ponente è del Cattai, e l'altra verso iscirocco va verso il gran mare alla gran provincia d'Eumangi. E sappiate veramente che l'uomo cavalca per ponente per la provincia del Cattai ben dieci giornate, tuttavia trovando belle cittadi e belle castella di mercatanzie e d'arti, e belle vigne e àl-bori assai, e gente dimestiche. Quivi non ha altro da ricordare: perciò ci partiamo di qui, e andremo ad un reame chiamato Taianfu.

XCI
Del reame di Taianfu.

Quando l'uomo si parte di questa città di Giocui, cavalcando dieci giornate truova uno reame chiamato Taianfu. E di capo di questa provincia ove noi siamo venuti è una città c'ha nome Tinafu, ove si fa mercatanzia e arti assai; e quivi si fanno molti fornimenti che bisognano ad oste del gran sire. Quivi hae molto vino, e per tutta la pro-vincia del Cattai non ha vino se non in questa città; e questa ne fornisce tutte le provin-cie d'intorno. Quivi si fa molta seta, peroché v'ha molti mori gensi e molti vermini che la fanno. E quando l'uomo si parte di Tinafu, l'uomo cavalca per ponente bene sette giornate per molte belle contrade, ove si truovano molte ville e castella assai di molta mercatanzia e d'arti. Di capo delle sette giornate si truova una città che si chiama Pianfu, ov'ha molti mercatanti, ove si fa molta seta e piue altre arti. Or lasciamo questa, e di-rovvi d'un castello chiamato Caitui.

XCII
Del castello del Caitui.

E quando l'uomo si parte di Pianfu e va per ponente due giornate, e' truova un bel castello c'ha nome Caitui, lo quale fece fare uno re lo quale fu chiamato lo re Dor. In questo castello èe un molto bello palagio, ove hae una molto bella sala, molto bene dipinta di tutti gli re che anticamente sono istati re di quel reame; ed è questo molto bella cosa a vedere. E di questo re Dor si vi conterò una molto bella novella, d'un fatto che fu tra lui e 'l presto Giovanni. E questi è in sì forte luogo, che 'l preste Giovanni no gli poteva venire addosso, e aveano guerra insieme, secondo che diceano quegli di quella contrada. Il preste Giovanni n'avea grande ira; e sette valletti del preste Giovanni si gli

86

*As time went on more than a dozen books were produced containing illustrations printed on the lithographic handpress of the Officina Bodoni....
For several lithographically illustrated books – among them the magnificent* Il Milione *by Marco Polo with Massimo Campigli's drawings on stone – [Mardersteig] chose very large formats in the proportion of about 4:3, so as to give the artists plenty of width.*

– Hans Schmoller, *The Officina Bodoni.* Verona, Edizioni Valdonega, 1980.

23. [The Holy Bible], APOKALYPSE

Bauersche Giesserei, Frankfurt am Main, 1943

Hand-colored lithographs
by Max Beckmann
(1884–1950).

About 40 copies: 10 uncolored.

Printed at the Bauersche Giesserei
from its Legend type designed by
F. H. Ernst Schneidler.

15⅜ x 11¾ in.

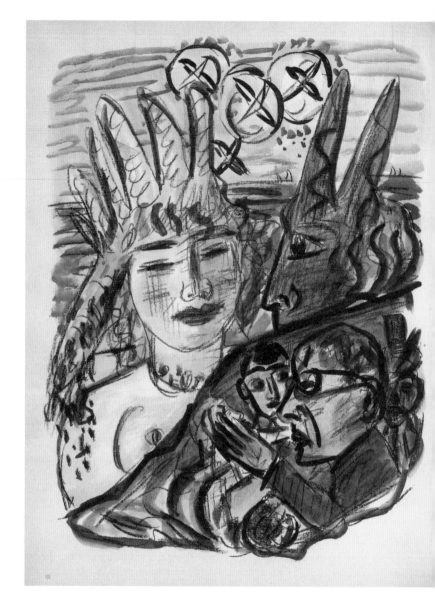

*One can only imagine the harsh
conditions under which this book was
produced, utilizing prints by an exiled
German artist working in occupied
Holland at the height of the war. The
publisher, Georg Hartmann of the
Bauer typefoundry in Frankfurt, took
great risks in issuing this edition, which
is a thinly veiled comment on the Nazi
régime. Despite the trying circumstances
they created a masterpiece of art and
typography.*

und große macht. Und ich sah seiner häupter eines, als wäre es
tödlich wund; und seine tödliche wunde ward heil. Und der
ganze erdboden verwunderte sich des tieres, und beteten den
drachen an, der dem tier die macht gab, und beteten das tier an
und sprachen: Wer ist dem tier gleich? und wer kann mit ihm
kriegen? Und es ward ihm gegeben ein mund zu reden große
dinge und lästerungen, und ward ihm gegeben, daß es mit ihm
währte zwei und vierzig monden lang. Und es tat seinen mund
auf zur lästerung gegen Gott, zu lästern seinen namen und
seine hütte und die im himmel wohnen. Und ihm ward gegeben
zu streiten mit den heiligen und sie zu überwinden; und ihm
ward gegeben macht über alle geschlechter und sprachen und
heiden. Und alle, die auf erden wohnen, beten es an, deren namen
nicht geschrieben sind in dem lebensbuch des lammes, das erwürget
ist, von anfang der welt. Hat jemand ohren, der höre! So
jemand in das gefängnis führet, der wird in das gefängnis
gehen; so jemand mit dem schwert tötet, der muß mit dem
schwert getötet werden. Hie ist geduld und glaube der heiligen.
Und ich sah ein ander tier aufsteigen aus der erde; und hatte
zwei hörner gleichwie ein lamm und redete wie ein drache.

45

*In 1941, while an émigré in Amsterdam
(where he stayed from 1937 to 1947),
Max Beckmann received a generous
commission from his Frankfurt
friend G. Hartmann to illustrate the
Apocalypse. Intensive work on the
project continued for four months....
The twenty-seven crayon lithographs
are, with the pen-and-ink drawings for
part two of* Faust, *the major work of
Beckmann's late period.*

– Karl Dachs and Elisabeth Klemm,
Thesaurus Librorum. Wiesbaden, Dr.
Ludwig Reichert Verlag, 1983.
[Translated from the German]

24. Henri de Montherlant, PASIPHAÉ, CHANT DE MINOS (LES CRÉTOIS)

Martin Fabiani Editeur, Paris, 1944

Linoleum cuts
by Henri Matisse
(1869–1954).

250 copies: 30 on Japan paper with
an additional suite of the prints.

Designed by Matisse, printed by
Fequet et Baudier on Arches paper.

12¹³⁄₁₆ x 9¾ in.

PASIPHAÉ

rop tard. Il faut rester seule. Depuis
que je t'ai parlé, tu ne m'as pas regardée
une fois. Est-ce que déjà je n'aurais plus une
face humaine? Mais qui te dit que ce n'est pas
une face divine?

LA NOURRICE

h bien, je te regarde.

PASIPHAÉ

our me montrer l'horreur dans tes yeux.

82

*The deep black backgrounds of the
white-line linoleum cuts and black text
are relieved by the red initials created
by Matisse for this volume. The effect of
the white-on-black lines in these prints
is just about the exact opposite of the
delicate black lines of the etchings for
Matisse's Mallarmé (no. 16), but both are
successful in their different ways.*

70

 LA NOURRICE

auvre reine !

 PASIPHAÉ

ourquoi dis-tu : « Pauvre reine ! » ?

 LA NOURRICE

arce que je te vois malheureuse.

PASIPHAÉ

 beau jour ! » N'ai-je pas dit : « O beau jour ! » ?

For the Pasiphaé Matisse went to infinite pains. The white-line lino-cuts for the illustrations and decorations are without doubt the noblest existing work in this medium; only Picasso's rival them for sheer virtuosity. No great artist has submitted himself more to the discipline of the page and to typographical considerations than Matisse in both this and his Poésies (Mallarmé). . . . The medium of lino enabled him to vary the line's thickness with ease and, where necessary, to obtain sweeping curves without angularity. He has provided his own account of the problem of balancing the black page of his hors-texte with the relatively white page of the facing text. This he accomplishes by bringing the black page close to the verso (the left-hand page) so that the eye takes in the double page as a whole. He goes on to justify his use of red for the initial letters which he purposely designed in severe forms to counteract the somewhat funereal effect of so much black.

– W. J. Strachan, *The Artist and the Book in France*. New York, George Wittenborn, 1969.

25. [The Holy Bible], THE CREATION

Editiones Officina Bodoni, Verona, and Pantheon Books, New York, 1948

Woodcuts
by Frans Masereel
(1889–1972).

100 copies. Also 25 copies with
German text.

Printed by Giovanni Mardersteig from
Stempel Garamond type (modified) at
the Officina Bodoni.

15⅛ x 11 in.

*The publisher Kurt Wolff, who was
a friend of Mardersteig's, had a great
influence on twentieth-century book
production, first under his own name
(Kurt Wolff Verlag) in Europe, then
at Pantheon Books when he moved
to America as a Hitler refugee, and
later with his own imprint as part of
Harcourt Brace. He was intimately
involved as publisher of this book, as
well as the Kirchner (no. 2), Shahn
(no. 29), and Calder (no. 31) works.*

wise, she took of the fruit thereof, and did eat, and gave also unto her husband with her; and he did eat. And the eyes of them both were opened, and they knew that they were naked; and they sewed fig leaves together, and made themselves aprons. And they heard the voice of the Lord God walking in the garden in the cool of the day: and Adam and his wife hid themselves from the presence of the Lord God amongst the trees of the garden. And the Lord God called unto Adam, and said unto him, Where art thou? And he said, I heard thy voice in the garden, and I was afraid, because I was naked; and I hid myself. And he said, Who told thee that thou wast naked? Hast thou eaten of the tree, whereof I commanded thee that thou shouldest not eat? And the man said, The woman whom thou gavest to be with me, she gave me of the tree, and I did eat. And the Lord God said unto the woman, What is this that thou hast done? And the woman said, The serpent beguiled me, and I did eat. And the Lord God said unto the serpent, Because thou hast done this, thou art cursed above all cattle, and above every beast of the field; upon thy belly shalt thou go, and dust shalt thou eat all the days of thy life: and I will put enmity between thee and the woman, and between thy seed and her seed; it shall bruise thy head, and thou shalt bruise his heel. Unto the woman he said, I will greatly mul-

24

Mardersteig believed that printing on the handpress encourages in the printer the strictest attention to detail and makes possible the greatest subtlety in impression. For him the handpress was like an artist's pencil, under the direct control of the printer's hand and eye, enabling immediate and direct expression of his conceptions and designs. Only he who has printed with the handpress and accustomed his eye to its slow progress can appreciate the importance of every detail. From his point of view even the most perfect machine can never replace the handpress.

– John Barr, *The Officina Bodoni*. London, The British Library, 1978.

26. Eugène Guillevic, LES MURS

Les Éditions du Livre, Paris, 1950

Lithographs
by Jean Dubuffet
(1901–1985).

172 copies: 12 on Japan paper with two
additional suites of the prints, 160 on
Montval paper.

Text printed in Bodoni Bold type by
Joseph Zichieri, lithographs printed by
Mourlot Frères.

15 x 11⅛ in.

**Un homme
Est devenu jaloux des murs**

**Et puis, têtu, c'est des racines
Qu'il ne peut plus se démêler.**

**Il asseoit à l'écart
Un corps habitué,**

**Exclut les portes,
Exclut le temps,
Voit dans le noir**

Et dit : amour.

*The typography of this book is a prime
example of matching typeface to art-
work: the extremely bold Bodoni font
is the perfect complement to the blacks
and dark grays of Dubuffet's litho-
graphs. In their bold inelegance both
prints and font also show great affinity
for each other.*

74

Dubuffet's illustrations to Les Murs, a text by Guillevic. . . . are among his most important. The figure of a man against a wall, an Art Brut distortion, also shows the artist's growing fascination with textures – a feature of his later work.

– W. J. Strachan, *The Artist and the Book in France.* New York, George Wittenborn, 1969.

27. Honoré de Balzac, DIE LÄSSLICHE SÜNDE

Birkhäuser, Basel, 1951

Multi-color woodcuts
by Felix Hoffmann
(1911-1975).

350 copies.

Designed by Jan Tschichold, printed
from Monotype Poliphilus type at the
Offizin E. Birkhäuser.

5¼ x 7½ in.

70 entlang hätten schauen müssen und daß sie bewundernd auf vollendet schönen Formen verweilten, welche sich lustverheißend und verführerisch unter dem Rock der Seneschallin in den blütenweißen Strümpfen abhoben. So konnte es nicht anders kommen und müßte unausweichlich dazu führen, daß ein schwacher Edelknabe sich in einer Falle fing, in welcher auch der kräftigste Ritter noch so gerne hätte schwach werden wollen.

Als sie sich nun so lange hin- und hergekuschelt und zurechtgerückt hatte, bis sie in der Stellung dasaß, die ihr für ihr Vorhaben am ehesten geeignet schien und den Pagen am sichersten zu Fall bringen konnte, rief sie leise und sanft: Oh, Renatus! Und Renatus, der, wie sie wohl wußte, sich im Vorzimmer bei den Schloßwachen aufhielt, kam unverzüglich herbeigelaufen und streckte alsogleich seinen braunen Lockenkopf durch den Türvorhang. Was befehlt Ihr, Herrin? fragte der Page. Und er hielt vor großer Ehrerbietung sein karmesinrotes Samtkäpplein in der Hand, und dies Käpplein war minder rot als seine leckern und frischen Grübchenwangen. Kommt näher, hauchte sie mit leiser, bebender Stimme, denn das Bübchen erweckte in ihrem Innern ein so übermächtiges Gelüste, daß sie darob gänzlich von Sinnen ward.

Freilich war auch kein Edelstein so strahlend licht wie des Renatus Augenpaar, kein Sammet so weiß

The important twentieth-century typographer Jan Tschichold is famous for his radical shift from avant-garde typography (he wrote the manifesto Die Neue Typographie *in 1928) to extreme classicism. This edition of Balzac's story is from his later period, when classical typefaces (in this case Monotype Poliphilus, based on a fifteenth-century Aldine model) were carefully arranged and printed on fine papers (like the Hahnemühle mould-made sheet used here).*

76

In 1941 [Jan Tschichold] was summoned by the thriving Basel publishing firm of Birkhäuser to supervise its planned new series of classic literature, in addition to other collections. This activity in designing books for conservative publishers during the war in neutral Switzerland, combined with his recent historical research, led him to consolidate his leanings towards classical typography. In general he spurned ornament, in line with the austerity he appreciated in many products of the British New Traditionalism. . . . Tschichold now made use of the range of classic book types revived by the Monotype Corporation, which had an active office in Switzerland.

– Christopher Burke, *Active Literature: Jan Tschichold and New Typography.* London, Hyphen Press, 2007.

28. Adrian de Monluc [Guillaume de Vaux], LA MAIGRE

Le Degré Quarante et Un [Iliazd], Paris, 1952

Engravings and etchings
by Pablo Picasso
(1881–1973).

74 copies: 60 on chine paper, 14 on
Japan paper.

Designed by Iliazd, set in Gill Sans
Light type, all caps, printed by
L'Imprimerie Union, etchings printed
by Atelier Lacourière.

16¼ x 9⅛ in.

*Ilia Mikhailovich Zdanevich (who
changed his name to Iliazd in 1919)
was among the most important
publishers of* livres d'artistes *in the
twentieth century. After early books
where he experimented with Russian
constructivist typography, he moved on
to fine editions with exceptional art-
ists, including Joan Miró, Max Ernst
(no. 39), Giacometti, and Picasso, with
whom he produced nine volumes.
Picasso's prints for this volume are
among his most dynamic work.*

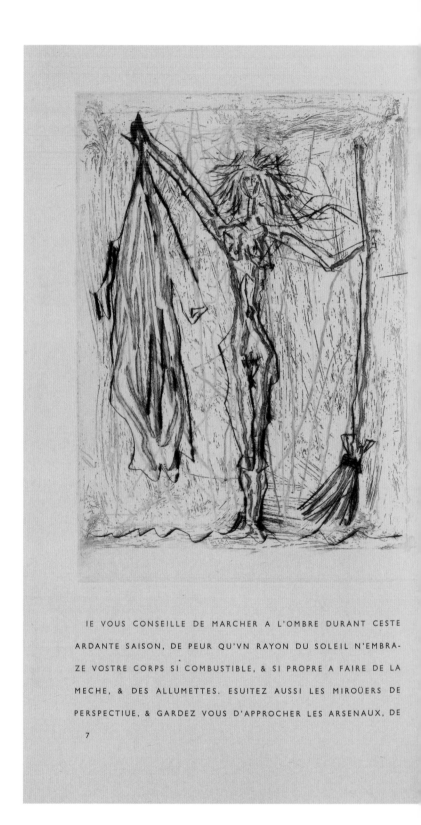

IE VOUS CONSEILLE DE MARCHER A L'OMBRE DURANT CESTE
ARDANTE SAISON, DE PEUR QU'VN RAYON DU SOLEIL N'EMBRA-
ZE VOSTRE CORPS SI COMBUSTIBLE, & SI PROPRE A FAIRE DE LA
MECHE, & DES ALLUMETTES. ESUITEZ AUSSI LES MIROÜERS DE
PERSPECTIUE, & GARDEZ VOUS D'APPROCHER LES ARSENAUX, DE

7

PEUR QUE BRONCHANT A QUELQUE PIERRE, VNE ESTINCELLE DE
FEU NE CAUSE VOSTRE RUINE, & CELLE DE QUELQUE GRANDE
CITÉ. IE SUIS D'ADUIS QUE VOUS FREQUENTIEZ LES RIUIERES,
NE CRAIGNEZ PAS D'ALLER A FONDS, LES ROSEAUX, LES LIE-
GES, & LES CITROÜILLES SECHES NE S'ENFONCENT IAMAIS. VOUS

8

Picasso's ten mixed etchings to Adrian de Monluc's La Maigre *(1952) express [a] spirit of* dépouillement. . . . *The aquatint background on a toned paper with the drypoint lines does full justice to Picasso's work. Impeccably printed at Lacourière's, the book is described as "mise en lumière et en page par Iliazd" – one of the great* maîtres d'oeuvre *of contemporary France.*

– W. J. Strachan, *The Artist and the Book in France.* New York, George Wittenborn, 1969.

29. Moses de Leon (*trans.* Maurice Samuel), THE ALPHABET OF CREATION

Pantheon Books, New York, 1954

Drawings, printed from line blocks, by Ben Shahn (1898–1969).

550 copies: 50 deluxe copies on Umbria paper with an original drawing.

Designed by Joseph Blumenthal at The Spiral Press and printed from his Emerson type on mould-made Rives paper, with 50 deluxe copies on hand-made Umbria paper.

10⅝ x 6½ in.

Blumenthal and Shahn collaborated on several fine editions, all distinguished by exceptional presswork and layout (hallmarks of virtually all Spiral Press volumes) in combination with Shahn's powerful drawings, with their distinctive line.

with a pen of flaming fire. They gathered around about God

and one after another spoke and entreated, each one, that the world be created through him.

Ben Shahn © Estate of Ben Shahn/Licensed by VAGA, New York, NY

The first to step forward was

Tav. "O Lord of the World,"

said he, "be it Thy will to

create the world through me,

Two of my favorite books were made with Ben Shahn. The Alphabet of Creation *is one of the legends from the* Sefer Ha-Zohar, *or Book of Splendor, an ancient Gnostic work written in Aramaic by a thirteenth-century Spanish scholar. . . . Ideally, illustration should be a work of art that will complement and enhance a worthy text, not be competitive. Shahn agreed, and I believe we succeeded in achieving these desirable ends in* The Alphabet of Creation *and in our edition of* Ecclesiastes *– books that grew out of personal enthusiasms.*

– Joseph Blumenthal, *Typographic Years.* New York, Frederic C. Beil and The Grolier Club, 1982.

30. Glenway Westcott, *trans.,* TWELVE FABLES OF AESOP

The Museum of Modern Art, New York, 1954

Woodcuts
by Antonio Frasconi
(b. 1919).

1000 copies.

Designed by Joseph Blumenthal,
printed at The Spiral Press on
Rives paper from his Emerson type.

The Hare with Ability and

the Tortoise with Staying Power

A lively young hare and an old tortoise lived near a

racetrack, and the hare teased the tortoise; and one day,

when the horses were running somewhere else, and

they had the place to themselves, they engaged in a race.

The hare, calculating how long it was going to take his

It is not surprising that when Monroe Wheeler decided to initiate a program of livre d'artiste *publications at the Museum of Modern Art, he selected the printer Joseph Blumenthal and rising young artist Antonio Frasconi as collaborators for the first publication in the series. Both were among the most respected in their fields in America at the time. This edition of Aesop was a great success, and it was later reprinted many times in an inexpensive pamphlet format.*

adversary, confident in his streamlined figure and

powerful hind legs, got bored and sleepy, and decided

to take time out for a nap. He overslept. Meanwhile

the tortoise crept along in front of the grand-stand,

slow but indefatigable and victorious.

Persistent ambition without talent breaks no record.

Talent without character wins no race.

In 1952 I was invited to produce an edition of Twelve Fables of Aesop, newly narrated by Glenway Westcott and illustrated by Antonio Frasconi. Its colophon tells the story: "This book, the first of a series of limited editions to be published by The Museum of Modern Art under the direction of Monroe Wheeler, has been designed and printed by Joseph Blumenthal at The Spiral Press, New York on Rives mould-made paper. The Emerson type has been set by hand, and the illustrations have been separately printed from the artist's original blocks. The edition is limited to 975 numbered copies and 25 lettered review copies, all signed by Mr. Frasconi, Mr. Westcott and Mr. Blumenthal." A second book in the series appeared in 1957 – Voyages, Six Poems by Hart Crane, with superb wood engravings by Leonard Baskin, designed and handsomely printed by Baskin at his Gehenna Press in Northampton, Massachusetts. With the Aesop and Voyages a very promising enterprise came to an untimely and regrettable end.

– Joseph Blumenthal, *Typographic Years*. New York, Frederic C. Beil and The Grolier Club, 1982.

31. Richard Wilbur, *ed. & trans.,* A BESTIARY

Pantheon Books, New York, 1955

Drawings (printed from photo-engraved line cuts)
by Alexander Calder
(1898–1976).

800 copies: 50 special copies on Rives mould-made paper.

Designed by Joseph Blumenthal, printed at The Spiral Press from Scotch and Bulmer types on Curtis paper.

12½ x 9¼ in.

THE MOUSE

A MOUSE'S NEST

I found a ball of grass among the hay
And progged it as I passed and went away;
And when I looked I fancied something stirred,
And turned agen and hoped to catch the bird —
When out an old mouse bolted in the wheats
With all her young ones hanging at her teats;
She looked so odd and so grotesque to me,
I ran and wondered what the thing could be,
And pushed the knapweed bunches where I stood;
Then the mouse hurried from the craking brood.
The young ones squeaked, and as I went away
She found her nest agen among the hay.
The water o'er the pebbles scarce could run
And broad old cesspools glittered in the sun.

John Clare

Joseph Blumenthal arranged the assorted texts for this bestiary using different line lengths and text areas, which are placed in different positions from page to page (unlike most books, where the text area and margins are handled consistently throughout). Calder's animals crawl all over the page also, creating a menagerie in book form.

The mice which haunted my house were not the common ones, which are said to have been introduced into the country, but a wild native kind not found in the village. I sent one to a distinguished naturalist, and it interested him much. When I was building, one of these had its nest underneath the house, and before I had laid the second floor, and swept out the shavings, would come out regularly at lunch time and pick up the crumbs at my feet. It probably had never seen a man before; and it soon became quite familiar, and would run over my shoes and up my clothes. It could readily ascend the sides of the room by short impulses, like a squirrel, which it resembled in its motions. At length, as I leaned with my elbow on the bench one day, it ran up my clothes, and along my sleeve, and round and round the paper which held my dinner, while I kept the latter close, and dodged and played at bo-peep with it; and when at last I held still a piece of cheese between my thumb and finger, it came and nibbled it, sitting in my hand, and afterward cleaned its face and paws, like a fly, and walked away.

H. D. Thoreau, *Walden*

One of the characteristics of the leopard is that in case it wounds a man and a mouse urinates on the wound, the man dies. It is very difficult to keep the mouse away from one wounded by a leopard. In fact, they sometimes go so far as to fix a bed for him in the midst of water and tie cats all around him for fear of the mice.

Usāmah ibn-Munqidh, *Memoirs*

17

Kurt Wolff asked me to design and print a bestiary to be published by Pantheon Books in a limited edition; the drawings of the many animals had already been completed by Alexander Calder following the typescript by the poet Richard Wilbur, editor and translator. I had never before met Calder, famous for his mobiles. When I asked him if the drawings were preliminary sketches he reduced me with a look that said they were absolutely final, of course. . . . A Calder bear hug at the end of the summer and a good book in late autumn were among the prizes in a friendly duel between book designer and artist. Both parties won.

–Joseph Blumenthal, *Typographic Years.* New York, Frederic C. Beil and The Grolier Club, 1982.

32. Hesiod, THEOGONIE

Maeght Editeur, Paris, 1955

Etchings
by Georges Braque
(1882–1963).

150 copies.

Printed by Fequet et Baudier
from Capitales Europe type
on Auvergne handmade paper.

17½ x 13¼ in.

ΘΕΟΓΟΝΙΑ

ΑΣΤΡΑ ΤΕ ΛΑΜΠΕΤΟΩΝΤΑ ΚΑΙ ΟΥΡΑΝΟΣ ΕΥΡΥΣ ΥΠΕΡΘΕΝ,
ΟΙ Τ' ΕΚ ΤΩΝ ΕΓΕΝΟΝΤΟ ΘΕΟΙ, ΔΩΤΗΡΕΣ ΕΑΩΝ,
ΩΣ Τ' ΑΦΕΝΟΣ ΔΑΣΣΑΝΤΟ ΚΑΙ ΩΣ ΤΙΜΑΣ ΔΙΕΛΟΝΤΟ,
ΗΔΕ ΚΑΙ ΩΣ ΤΑ ΠΡΩΤΑ ΠΟΛΥΠΤΥΧΟΝ ΕΣΧΟΝ ΟΛΥΜΠΟΝ.
ΤΑΥΤΑ ΜΟΙ ΕΣΠΕΤΕ, ΜΟΥΣΑΙ, ΟΛΥΜΠΙΑ ΔΩΜΑΤ' ΕΧΟΥΣΑΙ,
ΕΞ ΑΡΧΗΣ, ΚΑΙ ΕΙΠΑΘ', Ο ΤΙ ΠΡΩΤΟΝ ΓΕΝΕΤ' ΑΥΤΩΝ.
ΗΤΟΙ ΜΕΝ ΠΡΩΤΙΣΤΑ ΧΑΟΣ ΓΕΝΕΤ', ΑΥΤΑΡ ΕΠΕΙΤΑ
ΓΑΙ' ΕΥΡΥΣΤΕΡΝΟΣ, ΠΑΝΤΩΝ ΕΔΟΣ ΑΣΦΑΛΕΣ ΑΙΕΙ
ΑΘΑΝΑΤΩΝ, ΟΙ ΕΧΟΥΣΙ ΧΑΡΗ ΝΙΦΟΕΝΤΟΣ ΟΛΥΜΠΟΥ
ΤΑΡΤΑΡΑ Τ' ΗΕΡΟΕΝΤΑ ΜΥΧΩΙ ΧΘΟΝΟΣ ΕΥΡΥΟΔΕΙΗΣ,
ΗΔ' ΕΡΟΣ, ΟΣ ΚΑΛΛΙΣΤΟΣ ΕΝ ΑΘΑΝΑΤΟΙΣΙ ΘΕΟΙΣΙ,
ΛΥΣΙΜΕΛΗΣ, ΠΑΝΤΩΝ ΤΕ ΘΕΩΝ ΠΑΝΤΩΝ Τ' ΑΝΘΡΩΠΩΝ
ΔΑΜΝΑΤΑΙ ΕΝ ΣΤΗΘΕΣΣΙ ΝΟΟΝ ΚΑΙ ΕΠΙΦΡΟΝΑ ΒΟΥΛΗΝ.
ΕΚ ΧΑΕΟΣ Δ' ΕΡΕΒΟΣ ΤΕ ΜΕΛΑΙΝΑ ΤΕ ΝΥΞ ΕΓΕΝΟΝΤΟ·
ΝΥΚΤΟΣ Δ' ΑΥΤ' ΑΙΘΗΡ ΤΕ ΚΑΙ ΗΜΕΡΗ ΕΞΕΓΕΝΟΝΤΟ,
ΟΥΣ ΤΕΚΕ ΚΥΣΑΜΕΝΗ, ΕΡΕΒΕΙ ΦΙΛΟΤΗΤΙ ΜΙΓΕΙΣΑ.
ΓΑΙΑ ΔΕ ΤΟΙ ΠΡΩΤΟΝ ΜΕΝ ΕΓΕΙΝΑΤΟ ΙΣΟΝ ΕΑΥΤΗΙ
ΟΥΡΑΝΟΝ ΑΣΤΕΡΟΕΝΘ', ΙΝΑ ΜΙΝ ΠΕΡΙ ΠΑΝΤΑ ΚΑΛΥΠΤΟΙ,
ΟΦΡ' ΕΙΗ ΜΑΚΑΡΕΣΣΙ ΘΕΟΙΣ ΕΔΟΣ ΑΣΦΑΛΕΣ ΑΙΕΙ.
ΓΕΙΝΑΤΟ Δ' ΟΥΡΕΑ ΜΑΚΡΑ, ΘΕΩΝ ΧΑΡΙΕΝΤΑΣ ΕΝΑΥΛΟΥΣ,
ΝΥΜΦΕΩΝ, ΑΙ ΝΑΙΟΥΣΙΝ ΑΝ' ΟΥΡΕΑ ΒΗΣΣΗΕΝΤΑ.
Η ΔΕ ΚΑΙ ΑΤΡΥΓΕΤΟΝ ΠΕΛΑΓΟΣ ΤΕΚΕΝ, ΟΙΔΜΑΤΙ ΘΥΟΝ,
ΠΟΝΤΟΝ, ΑΤΕΡ ΦΙΛΟΤΗΤΟΣ ΕΦΙΜΕΡΟΥ· ΑΥΤΑΡ ΕΠΕΙΤΑ
ΟΥΡΑΝΩΙ ΕΥΝΗΘΕΙΣΑ ΤΕΚ' ΩΚΕΑΝΟΝ ΒΑΘΥΔΙΝΗΝ,
ΚΟΙΟΝ ΤΕ ΚΡΙΟΝ Θ' ΥΠΕΡΙΟΝΑ Τ' ΙΑΠΕΤΟΝ ΤΕ

14

Braque's cubist etchings have an affinity with Greek vase painting, as does the all-cap, monolined Greek typeface used for the text. The lines of the imagery and font are a good match for each other, and for Hesiod's classical text.

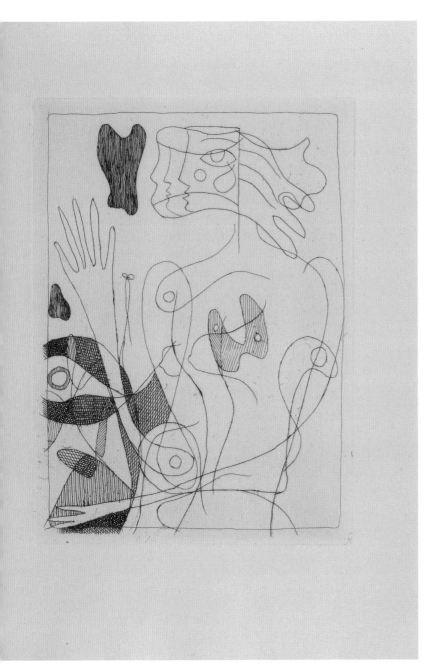

Hesiod's guide to the gods was a perfect setting for Braque's interest in archaic Greek figures, which may have been ignited by his association with the Greek publisher and art critic Christian Zervos. Zervos was to publish a number of Braque's preparatory drawings in his journal Cahiers d'art *in 1932, at which time Braque had completed sixteen prints. He still had not finished his work for the book by 1939 when Vollard, who had commissioned it, died. . . . [B]efore the book could be completed by Aimé Maeght in 1955, three plates were lost. New plates were made photographically from early printings, all the remarques on the existing plates were removed, and other plates . . . were added by the artist.*

– Riva Castleman, *A Century of Artists Books*. New York, The Museum of Modern Art, 1994.

33. Lucretius (*trans.* William Ellery Leonard), OF THE NATURE OF THINGS

The Limited Editions Club, New York, 1957

Wood engravings
by Paul Landacre
(1893–1963).

1,500 copies.

Designed by Ward Ritchie and printed
at his press from Janson types on
Strathmore paper.

9¼ x 5½ in.

*The wood engraver Paul Landacre and
the printer Ward Ritchie were friends
who lived not too far from each other
in Los Angeles. They collaborated on
several projects, including this volume,
one of a half dozen books printed by
The Ward Ritchie Press for the Limited
Editions Club, but the only one illus-
trated by Landacre for the venerable
publisher.*

SUMMARY OF BOOK II

Proem

I. *Atomic motions.*
 a. *Incessant motion of the atoms.*
 b. *Atomic velocity.*
 c. *Motion by gravity.*
 d. *Declination of the atoms.*
 e. *Conservation of matter and motion.*

II. *Atomic forms and their combinations.*
 a. *Indefinite number of atomic shapes.*
 b. *But not infinite.*
 c. *Although the atoms of each shape are infinite.*
 d. *Diverse, but not unlimited, combinations of atomic shapes in the unions.*

III. *Absence of secondary qualities (colour, odour, sound, heat, sense) among the atoms.*

IV. *Infinite worlds, and eternal creation and destruction of worlds.*

Book II

Proem

'Tis sweet, when, down the mighty main, the winds
Roll up its waste of waters, from the land
To watch another's labouring anguish far,
Not that we joyously delight that man
Should thus be smitten, but because 'tis sweet
To mark what evils we ourselves be spared;
'Tis sweet, again, to view the mighty strife
Of armies embattled yonder o'er the plains,
Ourselves no sharers in the peril; but naught
There is more goodly than to hold the high
Serene plateaus, well fortressed by the wise,
Whence thou may'st look below on other men

47

This was a difficult book to illustrate, since there is little to which an illustration can be tied, but Landacre managed to decorate it brilliantly in a semi-abstract manner. He cut a heading for each chapter and some ten vertical engravings with an accompanying smaller cut printed in color, which seems to add brilliance to the deep blacks and sharp whites of his engravings. While Bruce Rogers was originally scheduled to design this book, he was not sympathetic to Landacre's abstractions so Macy asked me to design and print it for The Limited Editions Club. As is customary with their books, a later edition was issued by The Heritage Club using less expensive materials.

– Ward Ritchie, *Some Books with Illustrations by Paul Landacre*. Los Angeles, Santa Susana Press, 1978.

34. Hart Crane, VOYAGES

The Museum of Modern Art, New York, 1957

Wood engravings
by Leonard Baskin
(1922–2000).

1,000 copies.

Designed by Leonard Baskin and printed at his Gehenna
Press from Perpetua type on Amalfi and Japan papers.

9½ x 11 in.

As well as being a noted artist and wood engraver, Baskin ran a highly respected private press, acting as both publisher and designer. His combination of talents is nearly unique in the history of these disciplines. This small volume deftly shows Baskin's skill in both fields. The sharp, clear Perpetua font (designed by the wood engraver and calligrapher Eric Gill; see nos. 12 and 14) is a perfect choice of type to complement the crisp wood engravings.

III

Infinite consanguinity it bears—
This tendered theme of you that light
Retrieves from sea plains where the sky
Resigns a breast that every wave enthrones;
While ribboned water lanes I wind
Are laved and scattered with no stroke
Wide from your side, whereto this hour
The sea lifts, also, reliquary hands.

And so, admitted through black swollen gates
That must arrest all distance otherwise,—
Past whirling pillars and lithe pediments,
Light wrestling there incessantly with light,
Star kissing star through wave on wave unto
Your body rocking!
 and where death, if shed,
Presumes no carnage, but this single change,—
Upon the steep floor flung from dawn to dawn
The silken skilled transmemberment of song;

Permit me voyage, love, into your hands...

Voyages is plainly bound in wrappers . . . but the interior shows a new sophistication. The title page is graced with a beautifully sharp engraving, and the other prints with which the book is adorned are displayed with verve and variety. Some are printed with the text, one is printed on green Moriki and pasted in, another is printed on tissue and unfolds into a two-page spread. And an exquisite engraving is printed in green on two sides of a sheet of tissue. After one side of the sheet had been printed, the block was turned on its side and the reverse side of the sheet was printed. The effect is both delicate and mysterious. Because of the thinness of the paper, both impressions are clearly discernible on both sides of the tissue, though the impressions can be distinguished by the slight difference in color. Since seven engravings are lavished on one poem, the text tends to be lost, but there's no denying the virtuosity and beauty of this book.

– Stephen Brook, *A Bibliography of the Gehenna Press 1942–1975*. Northampton, MA, J. P. Dwyer, 1976.

35. Michel Ferrand, GERMINAL

George Wittenborn, New York, 1958

Color etchings
by Terry Haass
(b. 1923).

75 copies.

Designed by Bert Clarke, printed from
Walbaum italic type at Clarke & Way;
etchings printed by the artist.

8½ x 6 in.

La fuite des graines de la main de l'homme,
c'est déjà l'envol.
Epoussetant les fleurs, au gré de son humeur,
le vent aussi fait le semeur.

Comme des petites pierres sèches, légères de poids,
lourdes de vie, les semences se terrent
au sommeil de l'hiver.
Partout d'infimes déclenchements, si chargés
de promesses surgissent des bulles-cellules,
filles serviles prédestinées.

The small etchings (printed by the artist
herself) in this diminutive book con-
taining a short poem combine to make
this a tiny gem. The scale of the plates,
type, and the book itself creates an inti-
macy rarely found in livres d'artistes.

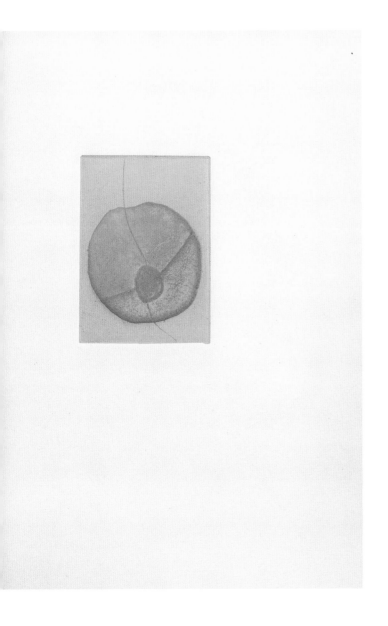

Her designs – abstract but always possessing some link with reality – are controlled but full of verve; the color, subdued when necessary, is often rich and glowing. The skilful abstract designs . . . remind us that she was trained under S.W. Hayter of Atelier 17, and in fact understudied him as chef d'école at one period in New York while he was in France.

– W. J. Strachan, *The Artist and the Book in France*. New York, George Wittenborn, 1969.

36. Paul Eluard, A TOUTE ÉPREUVE

Gérard Cramer, Geneva, 1958

Color woodcuts (a few with collage)
by Joan Miró
(1893–1983).

130 copies: 20 with an extra suite of
the woodcuts and 6 with two sets of
suites on different papers.

Designed by Gérald Cramer, Paul
Eluard, and Joan Miró, text printed
from Didot type by Fequet et
Baudier, woodcuts printed by Atelier
Lacourière et Frélaut, on Arches paper.

12⁹⁄₁₆ x 9¹³⁄₁₆ in.

*Miró's relief prints, printed in an
assortment of bright colors carefully
arranged across double-page spreads,
make for one of the pinnacles of the
collaboration of the artist and the
book. The austere Didot typeface,
printed only in black and gray,
provides a strong contrast to the
playful, colorful artwork.*

94

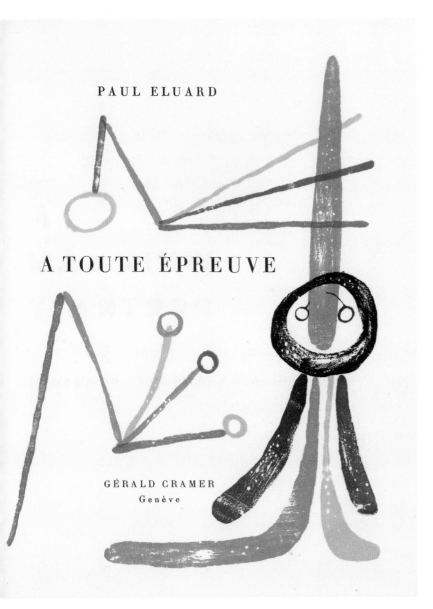

I am completely absorbed by this damn book.... I hope to create something sensational, the most important achievement in engraving since Gauguin.... What matters is that a book have all the dignity of a marble sculpture.... I should have to change even successful designs, that a single comma on the preceding page or the dot of an i on the page following could shatter what I had made separately.... I have respected your typography absolutely.

– Joan Miró, as quoted in the introduction to the facsimile of *A Toute Épreuve*. New York, George Braziller, 1984.

37. Walt Whitman, A WHITMAN PORTRAIT

Privately printed, South Norwalk, CT, 1960

Woodcuts
by Antonio Frasconi
(b. 1919).

525 copies.

Designed by Antonio Frasconi and
Joseph Blumenthal, printed from
Bodoni and Futura Bold display type
at The Spiral Press on Niddegen and
handmade Goyu paper.

7⅜ x 5¼ in.

A

WHITMAN

PORTRAIT

Woodcuts by **ANTONIO FRASCONI**

*Many artists (including Max Weber,
Ben Shahn, and Alexander Calder; see
nos. 6, 29, and 31) collaborated with
the printer Joseph Blumenthal at his
Spiral Press. The care Blumenthal took
with the presswork, allowing the relief
prints to show to their best advantage,
appealed to artists wishing to express
themselves in book form.*

Antonio Frasconi, internationally recognized master of the woodcut medium, has, in the course of a remarkable career spanning almost fifty years, created illustrated books which rank as major achievements in American graphic art.... From 1959 to 1965 Frasconi published a small-format series of literary portraits, made in collaboration with Joseph Blumenthal at The Spiral Press.... Walt Whitman was one of Frasconi's chief literary heroes because he felt his poetry best evoked the spirit of America – its land, its people and its democracy.

– Marilyn Symmes, in *"... Other Languages, Other Signs ..."*: *The Books of Antonio Frasconi*. Purchase, NY, Neuberger Museum of Art, State University of New York at Purchase, 1992.

38. John Ashbery, THE POEMS / Kenneth Koch, PERMA-NENTLY / Frank O'Hara, ODES / James Schuyler, SALUTE

Tiber Press, New York, 1960

Screen prints
by Joan Mitchell
(1925–1992),
Alfred Leslie (b. 1927),
Michael Goldberg (1924–2007),
and Grace Hartigan (b. 1922).

Four volumes.
225 copies.

Screen prints by the Tiber Press, text set in Walbaum type and printed letterpress by Brüder Hartmann, West Berlin.

17½ x 14 1/16 in.

ABSTENTIONS

Not the shy tourist, hopping up the salty steps of Rome—
The Piazza Venezia from a bus, the transparent emotions go by.
The old mines. Not
Just something resembling part of it
But all of it as it is not. The voice
"Please tell me that you love me" said,
The iron monuments drift by,
The arches nailed to wood,
The caves, blind fists,
Green seaweed on the black and blue water
And the friends' precision with excitement,
"The man who sees a cloud in Schenectady
Affects someone he does not know on the other side of the globe, who wants him
And we shall have that rose, Dutch work apart."
Blue towers, squeals, the yellow horses go by.

Therefore we have these few things.
It was a summer afternoon or evening, glory was in the gondola
On the percussive honeymoon.
But he thought of the nights the ruined homes
The gold tears shed for him.
Therefore we have these white bricks.
The bride wore white . . .

He wears a white suit, carries a white newspaper and apple, his hands and face are white;
The clouds sneer but go sailing into the white sky.

At the time this set of books was printed, the artists and poets were just beginning to make their mark in the world of art and literature. The silkscreen prints were relatively easy to produce with minimal equipment. The publisher went to the effort of having the text printed by a very fine shop in Germany, using the uncommon Walbaum font.

JOAN MITCHELL

These volumes bring together four poets and four painters of the New York School who knew each other's work well. The images were made directly on screens by the artists at the Tiber Press. This is Hartigan's only book illustrated with original prints. The Tiber Press was a collaborative effort between poetry editor Daisy Aldan, book designer Richard Miller, and art editor Floriano Vecchi, who supervised the screenprint production.

– Elizabeth Phillips and Tony Zwicker, *The American Livre de Peintre.* New York, The Grolier Club, 1993.

39. Max Ernst, 65 MAXIMILIANA

Le Degré Quarante et Un [Iliazd], Paris, 1964

Etchings
by Max Ernst
(1891–1976).

75 copies.

Designed by Iliazd, printed from Gill
Sans light all caps by Louis Barnier
and Raymond Billior, etchings printed
by Georges Visat and Louis Lemoine.

16 1/16 x 12 in.

Unusual (and labor-intensive) arrange-
ments of the text, as in this collabora-
tion with Max Ernst, are a hallmark of
Iliazd's pages. All of his Le Degré Quar-
ante et Un editions were hand set in
metal type in Gill Sans capitals, which
he meticulously letterspaced himself.

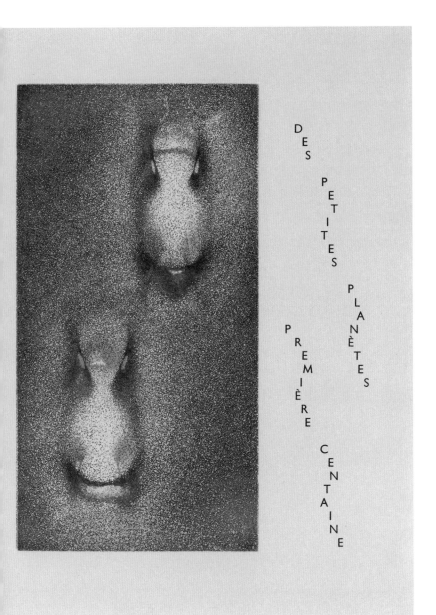

DES
PETITES
PLANÈTES
PREMIÈRE
CENTAINE

In 65 Maximiliana, *which demonstrates a close collaboration between the painter Max Ernst and the poet/publisher Iliazd, we find another dimension. . . . Here paleographer joins astronomer in a quest to decipher signs, where Ernst's "writings" recall the constellations of Ernst Wilhelm Tempel, the astronomer/lithographer who realized that signs "inter-respond" and interchange from microcosm to macrocosm.*

– Françoise Le Gris-Bergmann, in *Iliazd and the Illustrated Book.* New York, The Museum of Modern Art, 1987.

40. Frank O'Hara, IN MEMORY OF MY FEELINGS

The Museum of Modern Art, New York, 1967

Artworks by twenty-nine artists in various media reproduced by photo-offset:
Nell Blaine (1922–1996)
Norman Bluhm (1921–1999)
Joe Brainard (b. 1942)
John Button (1930–1982)
Giorgio Cavallon (1904–1988)
Allan d'Arcangelo (1930–1998)
Elaine de Kooning (1918–1989)
Willem de Kooning (1904–1997)
Helen Frankenthaler (b. 1928)
Jane Freilicher (b. 1924)
Michael Goldberg (b. 1924)
Philip Guston (1913–1980)
Grace Hartigan (b. 1922)
Al Held (1928–2005)
Jasper Johns (b. 1930)
Matsumi Kanemitsu (1922–1992)
Alex Katz (b. 1927)
Lee Krasner (1908–1984)
Roy Lichtenstein (1923–1997)
Marisol (b. 1930)
Joan Mitchell (1926–1992)
Robert Motherwell (1915–1991)
Reuben Nakian (1897–1986)
Barnett Newman (1905–1970)
Claes Oldenburg (b. 1929)
Robert Rauschenberg (1925–2008)
Larry Rivers (1923–2002)
Niki de Saint Phalle (1930–2002)
Jane Wilson (b. 1924)

2,500 copies.

Designed by Susan Draper Tundsi, set in Times New Roman type, and printed by photo-offset at Crafton Graphic Company on Mohawk Superfine paper.

12 x 9 in.

This is one of the few livres d'artistes *that reproduces artwork by offset lithography, printed on a machine-made paper (as opposed to the handmade and mould-made stocks most often used for deluxe editions), proving that fine editions can be produced even using modest components.*

LEE KRASNER

In Memory of My Feelings was published by the Museum in 1967 to honor its late curator. The book was edited by the poet Bill Berkson, who had been a close friend of O'Hara's and was then a guest editor in the Museum's Department of Publications. Berkson invited thirty artists who had known O'Hara, ranging from Willem de Kooning to Claes Oldenburg, from Joan Mitchell to Jasper Johns, to produce works to accompany his poems. The book was issued in a limited edition as a set of folded sheets held loose in a cloth-and-board folio that was itself contained in a slipcase.

– From the jacket flap copy to the 2005 reprint of the original edition. New York, The Museum of Modern Art, 2005.

41. C. P. Cavafy, FOURTEEN POEMS

Editions Alecto Limited, London, 1967

Etchings
by David Hockney
(b. 1937).

550 copies in editions A–D, E with 5
artist's proofs; 25 on Vellum Royale
paper.

Designed by Gordon House, text
printed by letterpress from Univers
type by Tillotsons, etchings printed by
Editions Alecto Limited.

13⅞ x 8⅞ in.

*A sans serif font (in this case Univers by
Adrian Frutiger) is employed to create
a harmonious effect with the images,
as was the case with the Kandinsky
and Kirchner volumes (nos. 1 and 2)
from early in the century – but here a
much lighter typeface is used to match
Hockney's characteristic light strokes.*

104

Two boys aged 23 or 24

He had been at the café from half past ten
expecting him soon to appear.
Midnight – he was still waiting.
One thirty; now the café was nearly empty.
He bored himself reading newspapers
mechanically. Of his miserable three shillings
only one remained; the rest he spent
on coffee and brandy while waiting for so long.
He had smoked up all his cigarettes.
He felt exhausted now by waiting. Because,
being alone for hours, disturbing thoughts
of having gone astray in his life began to gnaw at him.

But when he saw his friend come in, at once
fatigue, boredom and worries disappeared.

His friend brought unexpected news.
He had won sixty pounds at the casino.

Their handsome faces, superb youth,
the sensual love they felt for one another,
were now refreshed, renewed, invigorated
by the sixty pounds from the casino.

And full of joy and strength, beauty and emotion,
they went – not to the houses of their decent families
(where they were now unwanted anyway)
but to a very special place they knew
of ill repute. They took a bedroom there
ordered expensive drinks and went on drinking.

And when the expensive drinks were finished,
when it was nearly dawn,
content, they gave themselves to love.

In his autobiography, Hockney recalled that some of his Royal College of Art pictures of 1959–62 were "partly propaganda of something that hadn't been propagandized, especially among students, as a subject: homosexuality. I felt it should be done...." From that time he had wanted to illustrate the poems of Cavafy, the lyricist of Alexandria's gay subculture in the 1920s, even though he found the work "slightly old-fashioned" in its reticence. For this 1966 commission, Hockney made photographic studies in Beirut (thinking it might be as cosmopolitan as interwar Alexandria) and drew from live models and magazine photographs. He created some twenty etchings, of which thirteen were joined to poems chosen afterward. Devoid of modeling, young male couples are described with thin but sure lines, while aquatint shades certain subordinate areas as gray or black. The images exist parallel to the text; Hockney made no attempt to evoke Cavafy's rueful nostalgia for lost youths. Indeed, his depictions update the poems and his own previous gay subjects. The pickups lack furtiveness; some lovers look us straight in the eye. Their realistic delineation yet modest behavior are distinctive in Hockney's work to this date. They were an early but successful gamble on the acceptance of this artist as gay and of homosexuality as an artistic subject.

– Anne H. Hoy

42. Tony Towle, FIFTH STONE, SIXTH STONE

Universal Limited Art Editions, West Islip, NY, 1968

Etchings
by Lee Bontecou
(b. 1931).

42 copies.

Text printed from Times New Roman
type by Christopher Pullman, etchings
printed by Donn Steward at Universal
Limited Art Editions.

12 x 8⅝ in.

'Stone' in the titles of Lee Bontecou's lithographs refers to the lithographic

stone, in an abstract way, the ordinal number being the progression

of the completed editions. There are no specific titles which would

limit the imagination. There is a broad synthesis of nature,

nature in the sense of everything that is: the sky with its planets and stars,

the sea with its unending variety of extraordinary life,

birds and the life of the animals in general, including ourselves,

combined in the grandeur and mysticism of pure biology, pure chemistry.

*The dark tones of the etchings are
echoed in the relatively heavy Times
New Roman font, set with an extreme
amount of space between lines. The
printing on sensuous handmade paper
lends a powerfully tactile aspect to the
images and typography.*

*This illustrated book was made
as a tripartite collaboration: Tony
Towle's prose and poem in honor
of lithography accompanying Lee
Bontecou's six etchings, employing
aquatint grounds prepared by the
printer Donn Steward at Universal
Limited Art Editions. As a metal
sculptor, Bontecou was immediately
drawn to using intaglio on copper
plates. After many experiments, she
chose the same muslin she used in
her drawings and sculptures as a
surface for her print on the cover of
the portfolio.*

– Robert Flynn Johnson, *Artists' Books
in the Modern Era, 1870–2000.* [San
Francisco], Fine Arts Museum of San
Francisco, 2001.

43. Aristophanes, DIE FRÖSCHE

Ars Librorum, Frankfurt, 1968

Etchings
by Oskar Kokoschka
(1886–1980).

120 copies.

Designed by Gotthard de Beauclair,
hand-set in Janson types, printed
by Heinz Spaarwald at the Trajanus
Presse (text) and Hermann Steidle
(etchings) on handmade Richard de
Bas paper.

17⁹⁄₁₆ x 12⁵⁄₈ in.

One of the hallmarks of the best livres
d'artistes *is the high level of quality
in all aspects of production, from the
imagery and its reproduction to type-
setting, imposition, presswork, paper,
and housing. All of these facets of fine
book-making are shown at their best
in this meticulously produced edition,
published by the book designer Got-
thard de Beauclair (1907–1992) under
his private imprint, Ars Librorum.
De Beauclair was well known as the
head of book design at the Insel Verlag
(1928–1962), the important German
publishing house.*

Dionysos	Mach mir keine Angst,
	Du schreckst mich doch nicht ab!
Herakles	Dann Moor und Sumpf,
	Und Lachen Menschenkots, darin sich wälzt,
	Wer je das Gastrecht frevlerisch verletzt',
	Wer einen Knaben braucht' und nicht bezahlt',
	Die Mutter prügelt' und ins Angesicht
	Den Vater schlug, wer einen Meineid schwört',
	Und – abschrieb einen Vers von Morsimos.
Dionysos	Bei Gott, da muß auch hin, wer je gelernt
	Ein Waffentanzlied von Kinesias.
Herakles	Dann wird dich süßer Flötenhauch umwehn.
	Und schönstes Sonnenlicht, wie hier, und Haine
	Von Myrten, wo in sel'gen Scharen Fraun
	Und Männer ziehn mit Sang und Händeklatschen.
Dionysos	Wer sind denn die?
Herakles	Das sind die Eingeweihten.
Xanthias	Und ich – der Esel beim Mysterium!
	Nein, länger trag ich diesen Plunder nicht!
	Wirft sein Bündel weg
Herakles	Die sagen haarklein alles Nöt'ge dir.
	Denn ganz zunächst am Wege wohnen sie,
	Der führt zu Plutons Pforte. – Nun, Herr Bruder,
	Glück auf die Reise!
Dionysos	Lebe wohl, Herr Bruder! *Herakles ab*
Dionysos zu Xanthias	Du aber pack dein Bündel wieder auf!
Xanthias	Eh ichs recht weggelegt?
Dionysos	Und das geschwind!

22

After 1962 [Gotthard de Beauclair] founded a new enterprise: "Ars Librorum." ... There he produced expensive books to the highest standards, without any commercial restrictions. He chose the best papers for his editions, as well as the best binders, like Willy Pingel. ... The Ars Librorum editions were highlights of German book production after the war. ... Lucky are those book collectors who have in their collections editions designed by Gotthard de Beauclair – they are treasures of the best produced editions of the last century.

– Hermann Zapf, *Gotthard de Beauclair: Art & Literature through Typography & Design*. New York, The Grolier Club, 2006.

44. Phillip Greer, FLASH – NOVEMBER 22, 1963

Racolin Press, Briarcliff Manor, NY, [1968]

Silkscreen prints
by Andy Warhol
(1928–1987).

236 copies.

Designed by Andy Warhol, set in a
facsimile teletype font, printed by
Aetna Silk Screen Productions.

21½ x 21¼ in.

```
                FIRST DAY -- 11/22/63

     FIRST LEAD KENNEDY
       DALLAS, NOV. 22 -- PRESIDENT AND MRS. KENNEDY ARRIVEDX HERE
     TODAY IN THE SECOND DAY OF THEIR SWING THROUGH TEXAS.
       FOLLOWING TUMULTUOUS RECEPTION IN SAN ANTONIO, HOUSTON AND
     FORT WORTH YESTERDAY, THE PRESIDENT WAS XXXX SCHEDULED TO SPEAK
     TODAY TO A DEMOCRATIC LUNCHEON, AFTER A MOTORCADE TO THE DALLAS
     TRADE MART.
       THOUSANDS OF TEXANS XXXXX RIMMED THE LANDING AREA AT LOVE FIELD
     AS THE PRESIDENT'S PLANE, AIR FORCE ONE, TOUCHED DOWN AT 11:37 A.M.(CST)
                EDL152ACS

     FLASH
     DALLAS -- SHOTS AT KENNEDY MOTORCADE.
                CJ1235PCS

     BULLETIN -- PRECEDE KENNEDY
       DALLAS, NOV. 22 -- THREE SHOTS WERE FIRED AT PRESIDENT KENNEDY'S
     MOTORCADE IN DOWNTOWN DALLAS TODAY.  XXXXXXXX THE PRESIDENT'S CAR.
     WITH MRS. KENNEDY AND GOV. AND MRS. JOHN B. CONNALLY, JR., SPED
     OFF IMMEDIATELY IT WAS UNCLEAR WHETHER THERE WERE ANY CASUALTIES.XXXX
     XXXXXX XXXXXXXXXXX

                CJ1236PCS

     BULLETIN -- 1ST ADD SHOTS
       XXXXXX THE SHOTS RANG OUT AS THE PRESIDENT'S CAR WAS APPROACHING
     AN OVERPASS EN ROUTE TO THE TRADE MART, WHERE HE WAS TO DELIVER A
     SPEECH.  THEY APPEARED TO COME FROM BEHIND THE MOTORCADE.  (PICKUP
     1ST LEAD.....FOLLOWING TUMULTUOUS XXXX TO END)
```

Warhol's aesthetic, which played on the
popular graphics of the day, is displayed
to good advantage in this publication,
with its graphic silkscreen imagery in bold
colors in combination with teletype letters,
all printed on machine-made paper.

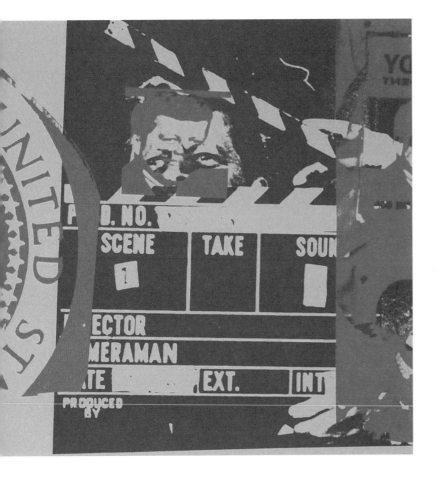

In 1968 the portfolio Flash – November 22, 1963 *was published by the Racolin Press, documenting the assassination of the President on 22 November 1963. The 18 sheets derive from a collection of press releases accompanying reports by Phillip Greer about the events of November 22 to 25: the murder, the arrest of the alleged offender Lee Harvey Oswald, the assassination of Oswald by Jack Ruby, and, finally, the funerals of the President and his murderer. Andy Warhol's monumental serigraphs do not merely replay the progress of the day; rather he has selected specific moments when the dramatic intensity of the events is most noteworthy. A series of "portraits" represent the President, his wife, his killer, the murder weapon, and President Kennedy's official seal. The bold, enlarged images ... use screen printing technology that has undergone a metamorphosis in this new application. The decorative flat colors, the superimposing of motifs, and the oversized dimensions result in a conscious alienation from the original photographs, as well as from the actual events and their reception.*

– Béatrice Hernad and Karin v. Maur, *Papiergesänge: Buchkunst in zwanzigsten Jahrhundert*. Munich, Prestel, 1992.

45. Gryphius, SONETTE

Otto Rohse Presse, Hamburg, 1970

Wood engravings and etchings by
Otto Rohse
(b. 1925).

195 copies.

Designed by Otto Rohse, printed from
Schneidler Mediaeval type on Rohse's
handpress, etchings printed by Peter
Fetthauer and Peter Loeding.

11¼ x 7¼ in.

Like Leonard Baskin (nos. 34 and 74),
Otto Rohse is an artist who is also
proprietor of his own private press,
where he oversees all aspects of the
typography, printing, and binding
of editions highlighted by his own
accomplished prints.

An die Sterne

Ihr Lichter, die ich nicht auf Erden satt kann schauen,
Ihr Fackeln, die ihr Nacht und schwarze Wolken trennt,
Als Diamanten spielt und ohn Aufhören brennt;
Ihr Blumen, die ihr schmückt des großen Himmels Auen,

Ihr Wächter, die, als Gott die Welt auf wollte bauen,
Sein Wort, die Weisheit selbst, mit rechten Namen nennt,
Die Gott allein recht mißt, die Gott allein recht kennt,
(Wir blinden Sterblichen, was wollen wir uns trauen!)

Ihr Bürgen meiner Lust, wie manche schöne Nacht
Hab ich, indem ich euch betrachtete, gewacht?
Herolde dieser Zeit, wann wird es doch geschehen,

Daß ich, der eurer nicht allhier vergessen kann,
Euch, deren Liebe mir steckt Herz und Geister an,
Von andern Sorgen frei werd unter mir besehen?

20

Most unusual for this era are the Gryphius volumes "Sonette" and "Gedichte und Epigramme." At first glance one is amazed at the surprising combination of both wood and copper engraving techniques, then one very quickly comprehends the logic of this. As with many books printed in the 17th and 18th centuries, the copper engravings, as large, complete-in-themselves illustrations, are the main focal points and do in fact divide the text pages into chapters whilst wood engravings in smaller and more modest formats are integrated into the actual text set in the Schneidler Mediaeval typeface.
Thus a rich and diversified impression is imparted.

– Eva-Maria Hanebutt-Benz in
Otto Rohse: 100 Wood Engravings.
Hamburg, Ernst Hauswedell, 1990.

46. André du Bouchet, AIR

Maeght, Paris, 1971

Etchings and lithographs
by Antoni Tàpies
(b. 1923).

180 copies: 50 with additional suite of
the prints.

Etchings on Richard de Bas Auvergne
paper printed by Adrien Maeght, text
set in Garamond type, printed by
L'Imprimerie Union.

$10^{15}/_{16}$ x $8^{11}/_{16}$ in.

*The strong, direct prints by Tàpies are
carefully placed on the two-page book
spreads, as is the small amount of text
set in Garamond type. Both are needed
to balance the relatively open pages:
they define the space together as neither
would alone.*

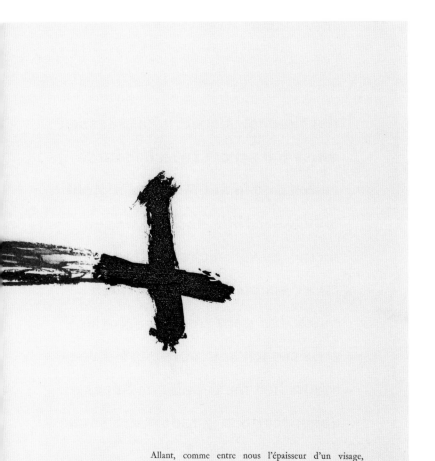

Allant, comme entre nous l'épaisseur d'un visage,
ô immobiles — et sous ce pas,

herbe à dos d'homme.

Attention to materials and gesture has been the hallmark of Antoni Tàpies's creativity. Working always in somber color, Tàpies develops an imagery of mysterious forms and signs. The severity of his works and the seriousness of his attitude distinguish it from much contemporary abstraction.

– Robert Flynn Johnson, *Artists' Books in the Modern Era, 1870–2000.* [San Francisco], Fine Arts Museum of San Francisco, 2001.

47. Franz Kafka, DER KÜBELREITER

Janus Press, Newark, VT, 1972

Relief prints
by Jerome Kaplan
(1920–1997).

100 copies: 10 with an additional suite
of the prints.

Designed by Claire van Vliet at the
Janus Press, printed by her from
Franklin Gothic and Times New
Roman types on Rives paper.

12½ x 11 in.

der Himmel ebenso, infolgedessen muss ich scharf zwischendurch reiten und in der Mitte beim Kohlenhändler Hilfe suchen. Gegen meine gewöhnlichen Bitten aber ist er schon abgestumpft; ich muss ihm ganz genau nachweisen, dass ich kein einziges Kohlenstäubchen mehr habe und dass er daher für mich geradezu die Sonne

The independent printer Claire van Vliet issued numerous illustrated editions at her private press in rural Vermont. Several include graphics by the printer herself, but she has also utilized the talents of other artists, as here where Jerome Kaplan's relief etchings and Van Vliet's powerful typography are a good fit for Kafka's dramatic short story.

[Kaplan's] enigmatic prints aptly fit the world of Kafka and they help to make Der Kübelreiter *the powerfully dramatic publication that it is. The eight relief etchings printed in black are strong graphic images developed by means of extremely delicate and subtle drawing coupled with rich surface modulation. In search for the least graceful typeface she could locate for this very harsh story Van Vliet arrived at the heavy 30 point Franklin Gothic for the German text, printed in brown so the visual activity of the type would not overpower the prints.*

– Ruth Fine, *The Janus Press 1955–75.* Burlington, The Robert Hull Fleming Museum, University of Vermont, 1975.

48. Rafael Alberti, A LA PINTURA

Universal Limited Art Editions, West Islip, NY, 1972

Color etchings and aquatints
by Robert Motherwell
(1915–1991).

52 copies.

Text printed by Juda Rosenberg, plates
printed by ULAE, on J.B. Green hand-
made paper.

25⁹⁄₁₆ x 37¹⁵⁄₁₆ in.

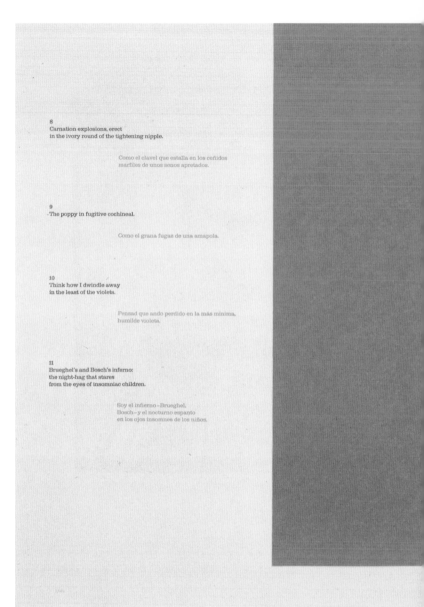

*Motherwell's graphic imagery is strik-
ing at this exceptionally large size (the
leaves are over three feet wide). This is
one of three major books with texts by
Spanish authors that Motherwell illus-
trated for various publishers (the others
are an Octavio Paz edition for the Lim-
ited Editions Club and another Alberti
text, El Negro, for Tyler Graphics).*

118

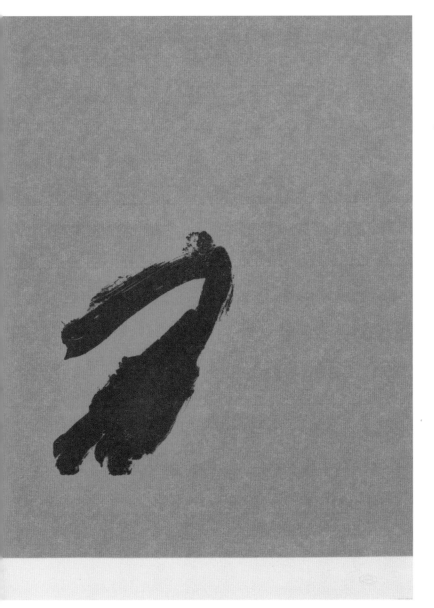

Robert Motherwell started making prints at ULAE in 1961 and in 1968 began work on the monumental book, A la pintura, *perhaps the most famous of all ULAE collaborations. Tatyana Grosman made an exception to her publishing policy in allowing the artist to work with an existing text. Long inspired by Spain and its civil war, Motherwell chose the Spanish poet Rafael Alberti's poems on the art of painting. The etchings are related to Motherwell's earlier paintings from the "Open" series, in which the image of a window is painted on a field of color. As in his paintings, color is an important element here, imbued with symbolic meaning. The Spanish text is printed in a variety of colors, while the English translation appears in black.*

– Elizabeth Phillips and Tony Zwicker, *The American Livre de Peintre*. New York, The Grolier Club, 1993.

49. Josef Albers, FORMULATION: ARTICULATION

Harry N. Abrams, New York, and Ives-Sillman, New Haven, 1972.

Silkscreen prints by Josef Albers (1888–1976).

1,000 copies.

Designed by Norman Ives, printed from Bodoni type by Eastern Press, color silkscreen prints printed by Sirocco Screenprinters.

15 x 20¹/₁₆ in.

These carefully printed silkscreens in hundreds (if not apparently thousands) of colors display the myriad variations that can be achieved through the juxtaposition of hues. The intensity and purity of color achievable by silkscreen is extraordinary. By using the book form (albeit unbound) Albers was able to explore color combinations sequentially.

Josef Albers Formulation : Articulation

Harry N. Abrams, Inc., New York and Ives-Sillman, Inc., New Haven

After retiring from his position as Chairman of the Art Department at Yale University in New Haven, Connecticut, Albers and his former students Norman Ives and Sewell Sillman set about making screenprints. . . . Formulation: Articulation is a printed compendium of Albers's compositional repertoire produced by the three men.

– Riva Castleman, *A Century of Artists Books*. New York, The Museum of Modern Art, 1994.

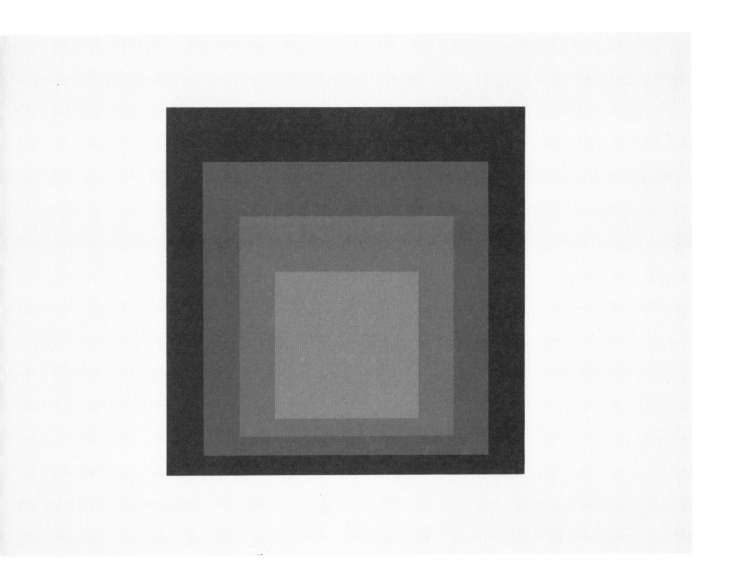

50. [Various authors], VOM LICHT

Galerie Rothe, Heidelberg, 1973

Embossings
by Günther Uecker
(b. 1930).

80 copies.

Text printed from Times New Roman
type by silkscreen at Siebdruck-
Technik; imagery printed by Tünn
Konerding.

18⅝ x 18¾ in.

Uecker's dynamic arrangement of nails embossed into the soft, textured paper is particularly impressive. Only by using a special handmade paper like this can the inkless images show to such good effect. The text is printed by silkscreen, and so the ink lies on the surface without penetrating the paper fibers, providing a stark contrast to the imagery.

Licht
Licht umzieht mich, umsingt mich, umfließt mich,
Spielend lasse ich meine Glieder im Fließenden plätschern –
Ein blankes Bassin umspannt mich die Straße,
Weit, weich, wiegend
Ich wasche mich ganz rein.
Aus euren Köpfen, ihr schwimmenden Straßenwanderer,
Die ihr nichts von mir wißt,
Gebrauche ich schimmerndes Augenweiß, meinen Leib zu bedecken,
Hell zu beschäumen,
Meinen jung sich hinbiegenden Schwimmerleib.
O wie ich hinfließe im Licht,
O wie ich zergehe,
Wie ich mich durchsichtig singe im Licht.
Ernst Wilhelm Lotz

An Gott
Du wehrst den guten und den bösen Sternen nicht;
All ihre Launen strömen.
In meiner Stirne schmerzt die Furche,
Die tiefe Krone mit dem düsteren Licht.

Und meine Welt ist still –
Du wehrtest meiner Laune nicht.
Gott, wo bist du?

Ich möchte nah an deinem Herzen lauschen,
Mit deiner fernsten Nähe mich vertauschen,
Wenn goldverklärt in deinem Reich
Aus tausendseligem Licht
All die guten und die bösen Brunnen rauschen.
Else Lasker-Schüler

One of the Gruppe Zero, which was most active in Düsseldorf during the early 1960s, Uecker used nails to alter his all-white canvases or placed them on their surfaces. The other artists in the group, Heinz Mack and Otto Piene, also made their works from aggressive elements such as metal punctures and fire. The resulting artworks were composed by the play of light created by such elements, and in Uecker's book about light, the uninked, embossed patterns made by nails produce shadows that echo the meaning and structure of each text.

– Riva Castleman, *A Century of Artists Books*. New York, The Museum of Modern Art, 1994.

51. Jorge Luis Borges, SEVEN SAXON POEMS

Plain Wrapper Press, Verona, Italy, 1974

Relief images
by Arnaldo Pomodoro
(b. 1926).

120 copies.

Designed by Richard Gabriel-
Rummonds, printed from Horizon
Light type on Richard de Bas
handmade paper at the Plain Wrapper
Press. Pomodoro's images blind-
embossed by Renzo Pavanello.

15⅜ x 14⁷⁄₁₆ in.

The Plain Wrapper Press was one of
the major handpress operations of the
latter part of the twentieth century. The
book's cover is an elaborate casting of
a Pomodoro design in polished bronze.
The concept of reproducing a sculptor's
artwork as blind-embossed images is
fresh and inspired.

UN SAJÓN
(A.D. 944)

Ya se había hundido la encorvada luna;
Lento en el alba el hombre rubio y rudo
Pisó con receloso pie desnudo
La arena minuciosa de la duna.

Más allá de la pálida bahía,
Blancas tierras miró y negros alcores,
En esa hora elemental del día
En que Dios no ha creado los colores.

Era tenaz. Obraron su fortuna
Remos, redes, arado, espada, escudo;
La dura mano que guerreaba pudo
Grabar con hierro una porfiada runa.

De una tierra de ciénagas venía
A esta que roen los pesados mares;
Sobre él se abovedaba como el día
El Destino, y también sobre sus lares,

Woden o Thunor, que con torpe mano
Engalanó de trapos y de clavos
Y en cuyo altar sacrificó inhumano
Caballos, perros, pájaros y esclavos.

Para cantar memorias o alabanzas
Amonedaba laboriosos nombres;
La guerra era el encuentro de los hombres
Y también el encuentro de las lanzas.

14

A UN POETA SAJÓN

Tú cuya carne que hoy es polvo y planeta
Pesó como la nuestra sobre la tierra,
Tú cuyos ojos vieron el sol, esa famosa estrella,
Tú que viviste no en el rígido ayer
Sino en el incesante presente,
En el último punto y ápice vertiginoso del tiempo,
Tú que en tu monasterio fuiste llamado
Por la antigua voz de la épica,
Tú que tejiste las palabras,
Tú que cantaste la victoria de Brunanburh
Y no la atribuiste al Señor
Sino a la espada de tu rey,
Tú que con júbilo feroz cantaste las espadas de hierro,
La vergüenza del viking,
El festín del cuervo y del águila,
Tú que en la oda militar congregaste
Las rituales metáforas de la estirpe,
Tú que en un tiempo sin historia
Viste en el ahora el ayer
Y en el sudor y sangre de Brunanburh
Un cristal de antiguas auroras,
Tú que tanto querías a tu Inglaterra
Y no la nombraste,
Hoy no eres otra cosa que unas palabras
Que los germanistas anotan.
Hoy no eres otra cosa que mi voz
Cuando revive tus palabras de hierro.

Pido a mis dioses o a la suma del tiempo
Que mis días merezcan el olvido,
Que mi nombre sea Nadie como el de Ulises,
Pero que algún verso perdure
En la noche propicia a la memoria
O en las mañanas de los hombres.

19

*

We can chart the different orientations represented by the [Kelmscott] Chaucer and Seven Saxon Poems. Morris was more interested in resurrection of the past, and then typographic style and illustration imprisoned his resurrection in a synthetic medievalism. Unfortunately, a substantial amount of private press publication fell into portions of this stance. Rummonds in text selection was contemporary. He had the harder job. Even though he was blessed in having texts from world-known figures, none had reached the iconographic stage of those Morris had selected. Rummonds's selection of art liberated the texts used. The art in a Plain Wrapper Press book refuses to be dated – thus assuring the viewer of a Plain Wrapper Press book a century from now an almost equal opportunity to come to the pages of text and rejoice in the feast of meaning with supportive art that allows various – but not dated – results. The same conclusion can be hoped for in Rummonds's selection of type.

– Decherd Turner, *A Sampler of Leaves from Plain Wrapper Press and Ex Ophidia Books*. Privately printed, 1996.

52. Samuel Beckett, FOIRADES / FIZZLES

Petersburg Press, New York and London, 1976

Etchings and one lithograph,
by Jasper Johns
(b. 1930).

300 copies.

Etchings printed by Atelier
Crommelynck, lithograph printed
by the Petersburg Press, text
printed from Caslon type by
Fequet et Baudier.

12^{15}⁄$_{16}$ x 9^{13}⁄$_{16}$ in.

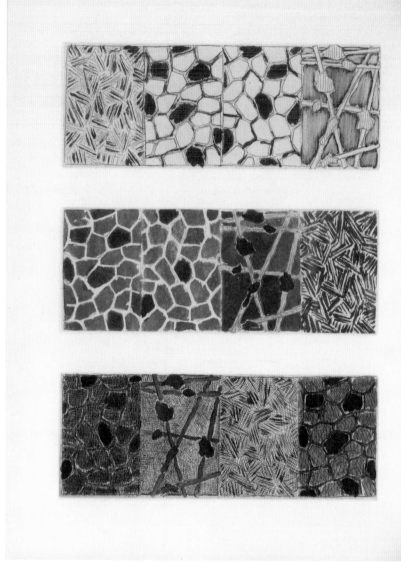

Jasper Johns © Jasper Johns/Licensed by VAGA, New York, NY

*Johns uses an unusually wide variety
of imagery – including his trademark
designs incorporating numerals, sten-
cilled words, flagstones, and hatchings
– in his prints illuminating Beckett's
text, printed in both the original French
and an English translation for this
Petersburg Press edition.*

I gave up before birth, it is not possible otherwise, but birth there had to be, it was he, I was inside, that's how I see it, it was he who wailed, he who saw the light, I didn't wail, I didn't see the light, it's impossible I should have a voice, impossible I should have thoughts, and I speak and think, I do the impossible, it is not possible otherwise, it was he who had a life, I didn't have a life, a life not worth having, because of me, he'll do himself to death, because of me, I'll tell the tale, the tale of his death, the end of his life and his death, his death alone would not be enough, not enough for me, if he rattles it's he who will rattle, I won't rattle, he who will die, I won't die, perhaps they will bury him, if they find him, I'll be inside, he'll rot, I won't rot, there will be nothing of him left but bones, I'll be inside, nothing left but dust, I'll be inside, it is not possible otherwise, that's how I see it, the end of his life and his death, how he will go about it, go about coming to an end, it's impossible I should know, I'll know, step by step, impossible I should tell, I'll tell, in the present, there will be no more talk of me, only of him, of the end of his life and his death, of his burial if they find him, that will be the end, I won't go on about worms, about bones and dust, no one cares about them, unless I'm bored in his dust, that would surprise me, as stiff as I was in his flesh, here long silence, perhaps he'll drown, he always wanted to drown, he didn't want them to find him, he can't want now any more, but he used to want to drown, he usen't to want them to find him, deep water and a millstone, urge spent like all the others, but why one day to the left, to the left and not elsewhither, here long silence, there will be no more I, he'll never say I any more, he'll never say anything any more, he won't talk to anyone, no one will talk to him, he won't talk to himself, he won't think any more, he'll go on, I'll be inside, he'll come to a place and drop, why there and not elsewhere, drop and sleep, badly because of me, he'll get up and go on, badly because of me, he can't stay still any more, because of me, he can't go on any more, because of me, there's nothing left in his head, I'll feed it all it needs.

It is not far-fetched, then, to regard the etchings of Foirades/Fizzles *as nothing less than analogues for the human condition: the torture borne of our perception of time through memory. For Johns and Beckett life consists of fragmented images, glimpsed during one's passage through the world, sometimes remembered, but never fixed.*

– Richard S. Field, in *Foirades / Fizzles: Echo and Allusion in the Art of Jasper Johns*. Los Angeles, The Grunwald Center for the Graphic Arts, Wight Art Gallery, UCLA, 1987.

53. Paul Smyth, THISTLES AND THORNS

Abattoir Editions, Omaha, 1977

Wood engravings
by Barry Moser
(b. 1940).

253 copies.

Designed by Harry Duncan and
printed from Bembo and Narrow
Bembo Italic types on Gutenberg Laid
paper at the Cummington Press.

10⅛ x 7 in.

ii.

Veils of sunlight drift on the air above stiff
Wreckage: Hai burned to the ground, the charred beams
Heaped like ruined hopes in the hearts of old men:
 This was a city,

This was what men made of their dread of silence.
Thousands raised this cry that collapsed in wild fire—
Piles of voices, carcass of safety, splintered
 Bones of a false god.

Now the seasons turn in their endless patience,
Soothe the closing wound in the landscape's belly.
Now the hill winds linger beneath the trees, all
 Outrage forgotten.

Men will fear their days, will refuse their lifetimes.
Every beam and brick was of terror. Men raise
Not the spirit's voice, nor its symbol; men raise
 Walls of denial.

Yet, a man will come to his life at last. They
Stood one morning staring at this, their wrecked walls:
Dying, each alone with his death, the men heard
 Terrible heartbeats.

24

Two of the leaders of modern American fine printing combined their talents on this book: Harry Duncan, proprietor of one of the major private presses of his time, and Barry Moser, a protégé of Leonard Baskin (see nos. 34 and 74) who would later go on to establish his own private press, The Pennyroyal Press.

iii.

I perceived my spirit in chance encounters:
Baffling footprints frozen in mud; a bare tree
Clutching spring's thin moon in its brittle arms; my
 Warning turned echo.

I declared my spirit: a drop of cool dew
Bending silver light from the morning's body
Casts an infinitesimal proof in hues deemed
 Hopelessly precious.

25

During World War II, students of literature at Cummington School were taken by the idea of becoming their own printers and publishers.. .. [Soon] the illustrator Wightman Williams, the teacher and poet Harry Duncan established the Cummington Press. ... Concerned with the content of words rather than their decoration, this operation never succumbed to the usual private press nostalgia. Duncan's typography and writings are exemplary exercises in simplicity.

– C. F. Hultenheim, *Typographica 1900–2000*. Stockholm, The Royal Library, 2002.

54. [The Holy Bible], THE APOCALYPSE

Arion Press, San Francisco, 1982

Woodcuts
by Jim Dine
(b. 1935).

150 copies.

Designed by Andrew Hoyem and
printed at his Arion Press from
Garamond Bold and Hadriano types
on Richard de Bas Auvergne paper.

15 x 11¼ in.

*Beyond his painting, Dine is best known
for his etchings and lithographs, but his
expressionistic woodcuts are a perfect
medium for this Arion Press printing
of the* The Apocalypse, *following in
a long tradition that includes Dürer,
Duvet, Dalí, and others.*

THE

A P O C A L Y P S E

THE REVELATION

of

SAINT JOHN THE DIVINE

THE LAST BOOK OF THE NEW TESTAMENT

FROM THE KING JAMES VERSION OF THE BIBLE, 1611,

WITH TWENTY-NINE PRINTS FROM WOODBLOCKS CUT BY

JIM DINE

PRINTED AND PUBLISHED IN 1982 BY

THE ARION PRESS

SAN FRANCISCO

Known for his Pop Art work of the 1960s, Jim Dine took an extreme departure in The Apocalypse. *Taking advantage of the dramatic qualities of the woodblock technique, Dine created highly expressionistic images to interpret the words of St. John's visionary text from the King James version of the Bible (1611).*

– Robert Flynn Johnson, *Artists' Books in the Modern Era, 1870–2000.* [San Francisco], Fine Arts Museum of San Francisco, 2001.

55. [The Holy Bible, *trans.* Martin Luther], DAS BUCH DES PROPHETEN IONA

TH Darmstadt, Darmstadt, 1982

Woodcuts
by Gerhard Marcks
(1889–1981).

380 copies.

Printed from Garamond type on Richard de Bas handmade paper by Walter Wilkes at the TH (Technische Hochschüle) Darmstadt.

11 x 7⅜ in.

ließ der herr einen großen wind aufs meer kommen, und es erhob sich ein großes ungewitter auf dem meer, daß man meinte, das schiff würde zerbrechen. Und die schiffsleute fürchteten sich und schrieen, ein jeglicher zu seinem gott, und warfen das gerät, das im schiff war, ins meer, daß es leichter würde. Aber Jona war hinunter in das schiff gestiegen, lag und schlief. Da trat zu ihm der schiffsherr und sprach zu ihm: was schläfst du? Stehe auf, rufe deinen gott an! ob vielleicht gott an uns gedenken wollte, daß wir nicht verdürben. Und einer sprach zum andern: kommt, wir wollen losen, daß wir erfahren, um welches willen es uns so übel gehe. Und da sie losten, traf's Jona. Da sprachen sie zu ihm: sage uns, warum geht es uns so übel? Was ist dein gewerbe, und wo kommst du her? Aus welchem lande bist du, und von welchem volk bist du? Er sprach zu

8

Marcks's woodcuts for Das Buch des Propheten Iona *were first used in a fine edition published by Richard von Sichowsky's Grillen Presse in 1950. For this new edition, Walter Wilkes of the TH Darmstadt uses an unusual cutting of Garamond type (from the Deberny et Peignot type foundry) and luscious Richard de Bas paper, making for a very different book.*

ihnen: ich bin ein Hebräer und fürchte den herrn, den gott des himmels, welcher gemacht hat das meer und das trockene. Da fürchteten sich die leute sehr und sprachen zu ihm: warum hast du denn solches getan? Denn sie wußten, daß er vor dem herrn floh; denn er hatte es ihnen gesagt. Da sprachen sie zu ihm: was sollen wir denn mit dir tun, daß uns das meer still werde? Denn das meer fuhr ungestüm. Er sprach zu ihnen: nehmt mich und werft mich ins meer, so wird euch das meer still werden. Denn ich weiß, daß solch groß ungewitter über euch kommt um meinetwillen. Und die leute trieben, daß sie wieder zu lande kämen; aber sie konnten nicht, denn das meer fuhr ungestüm wider sie. Da riefen sie zu dem herrn und sprachen: ach herr, laß uns nicht verderben um dieses mannes seele willen und rechne uns nicht zu unschuldig blut! denn du, herr, tust, wie dir's gefällt. Und sie nahmen Jona und war-

9

These beautiful woodcuts by the sculptor Gerhard Marcks were first used in 1950 for a small edition printed by the noted German typographer Richard von Sichowsky. About thirty years later, Marcks's widow allowed Walter Wilkes at the Technische Hochschüle Darmstadt to use these blocks, and those from other earlier volumes, to print new editions, each with different typography. It is interesting to note that this combination of modern woodcuts by a sculptor and classical typography on sumptuous handmade paper reflects the harmonious combination of type and illustration seen in many incunable volumes, as does the matching of woodcuts by the French sculptor Aristide Maillol with classical typography in Jenson roman, printed at the Cranach Press in Weimar a half century earlier [see no. 4].

– Jerry Kelly

56. Czesław Miłosz, THE VIEW

Library Fellows of the Whitney Museum of American Art, New York, 1985

Mezzotint prints
by Vija Celmins
(b. 1938).

120 copies.

Designed by Eleanor Caponigro,
printed from Bembo and Romulus
types on Twinrocker handmade paper
at the Stinehour Press. Mezzotints
printed by Doris Simmilink on Rives
BFK paper.

14⅞ x 10¾ in.

Mezzotint is a difficult print medium for an artist, rarely used. Eleanor Caponigro has a long history of skillful art book design, including numerous volumes of photography. Her talents are well suited to fine editions, as here. Exceptional materials – including paper specially made by hand for this edition – are a fitting setting for this Nobel Prize-winning poet.

TIDINGS

Of earthly civilization, what shall we say?

That it was a system of colored spheres cast in smoked glass,
Where a luminescent liquid thread kept winding and unwinding.

Or that it was an array of sunburst palaces
Shooting up from a dome with massive gates
Behind which walked a monstrosity without a face.

That every day lots were cast, and that whoever drew low
Was marched there as sacrifice: old men, children, young boys and young girls.

Or we may say otherwise: that we lived in a golden fleece,
In a rainbow net, in a cloud cocoon
Suspended from the branch of a galactic tree.
And our net was woven from the stuff of signs,
Hieroglyphs for the eye and ear, amorous rings.
A sound reverberated inward, sculpturing our time,
The flicker, flutter, twitter of our language.

For from what could we weave the boundary
Between within and without, light and abyss,
If not from ourselves, our own warm breath,
And lipstick and gauze and muslin,
From the heartbeat whose silence makes the world die?

Or perhaps we'll say nothing of earthly civilization.
For nobody really knows what it was.

134

With the third book in the series, I chose to work with the artist Vija Celmins, whose exquisite prints of horizon-less seascapes and starry skies seemed an ideal match with the poetry and lapidary printing that only a fine press book can offer. Her work had previously been collected by the Whitney Museum. . . . Vija set to work on the laborious process of creating exquisitely rendered mezzotints . . . of night skies, trees, and globes printed by the California-based fine printer Doris Simmilink. Eleanor Caponigro designed the book, constantly adjusting the location of the type even as Vija asked to move an image a millimeter to the left or a millimeter to the right, over and over again. (Obsession goes with the territory.) Eleanor commissioned a black-flecked, handmade paper from Twinrocker, one that very gently suggests the imagery in the book, but in no way competes with the artwork. It is an introspective and, I think, darkly beautiful book. . . . When I've offered to present a selection of Library Fellows books to candidates for book projects in the past decade, it has been Vija's book that most artists, from Robert Gober to Fred Tomaselli, have wanted to see.

– May Castleberry, in *Splendid Pages.* Toledo & New York, Toledo Museum of Art and Hudson Hills Press, 2003

57. Jamaica Kincaid,
ANNIE, GWEN, LILLY, PAM AND TULIP

Library Fellows of the Whitney Museum of American Art, New York, 1986

Lithographs
by Eric Fischl
(b. 1948).

145 copies.

Designed by Eleanor Caponigro,
printed from Gill Sans type by
Michael and Winifred Bixler,
lithographs printed by Palisades Press.

20¼ x 15 in.

"Annie, Pam, Gwen, Lilly: I see them in me in equal amounts, swirling like rare principles in a firmament. I feel that I have given them much love. I feel that in relation to myself they are superior beings. I feel that I shall see our past, this perfect place, and our future only through them, and I shall wish for them in my eternity. I have listened to the sound of them breathing in the dark, dark of night; I am aware of any slight transformation, any small degree of change that occurs in them for, even so, it occurs in me; I shall comfort Pam in the future she so clearly sees, hard and unhappy as it will be, and bound to it as she is like a wild animal to a sudden blinding light and a sudden blinding death in the dark; I shall comfort Gwen in much the same way that I comfort Pam, bound as she is to Pam as echo to a cave; I shall ever run up to greet Annie, hugging her and kissing her smooth face, reminding her that she is mortal and vulnerable; and Lilly almost lost to me even now, I shall love between frequent departures. I see then that I shall have much joy and much pain, all in the same splitting moment," *said Tulip.*

"Annie . . . ," *said Tulip.* "Pam . . . ," *said Gwen.* "Tulip . . . ," *said Lilly.*
"Lilly . . . ," *said Annie.* "Gwen . . . ," *said Pam.*

Fischl's somewhat uneasy portrayals go well with Kincaid's text about awakening sexuality. The superb printing and modern yet elegant typography, using the Gill Sans font cast by Michael & Winifred Bixler, who run one of the last Monotype composition facilities in the United States, are a good match for both text and lithographs.

Fischl's illustrations perfectly match the exotic heat of the tale and its latent sexuality. The prints are variously folded, tipped-in, and bound to echo the tale's unexpected turnings. He begins in black and white, presenting the five as if at some camp overnight. He moves on to luxuriant colors and suggestive scenes, showing them tempted to leave each other for the unknown.

– *The Print Collector's Newsletter,*
November–December, 1990.

58. Alberto Savinio,
THE DEPARTURE OF THE ARGONAUT

Petersburg Press, New York and London, 1986

Lithographs
by Francesco Clemente
(b. 1952).

232 copies.

Printed from Bembo type by Staib and
Mayer on Okawara paper, lithographs
printed by Rolf Neumann.

25⁹⁄₁₆ x 19¹¹⁄₁₆ in.

something, shouts, "y pas à dire, ils sont bien crânes!" I nod my head
with a gesture that might be interpreted as meaning: Don't get so
worked up, my good man, I never said those were humps on their
shoulders. Meanwhile, from the poop of the ship, which looks like a fat
hen dragging her ass over the water, the last strophe of the verse can be
heard: *un français doit vivre pour elle*
 pour elle un français doit mourir . . .
I only ponder the things I know: I know that further out, almost on
the high sea, a different transport ship sits waiting, black, smoking. It
didn't cross the channel to the applause of the crowds; it's packed with
soldiers dressed in gray green – brought to that ship on barges and
rafts – they'll weigh anchor as quiet as mice and they'll fight and die at
the most terrifying sector on the Macedonian front: elevation 1050.

There's another aspect to the Arabic influence here: Taranto lacks
women. No matter where I go, wherever I poke my head – in the
cafes, by the Marconi steps, at the Sant' Angelo theater, in the parks at
concert hour – I never seem to stumble across any skirts worthy of
hanging my expert glances on. Only periodically do I bump into half a
dozen coquettes who carry out their duty of enticing men with the
disciplined regularity of the *vigiles* (the military police). I have to ask
myself, in a city that's been subjected to all the shit that the whirling
Janissaries used to fling around, why aren't they in the habit of giving
out the battle cry of the peripatetics? . . . These contractors of "quick"
love, mistakenly called *allegre*, display on the contrary an attitude of
iron-like austerity: they reproduce perfectly the characteristics of
whores destined to be handed over by soldiers of fortune to their
mercenary troops as pay; (a custom nowadays practiced by certain
colonial governors who inspire these women to follow the Foreign
Legion column into the African interior along with the mules and
baggage) and those characteristics are: sunken, glassy eyes, unsightly

*Vividly colored lithographs as well as
monochromatic prints, small images
and full-bleed double-page spreads,
even renderings of maritime signal
flags – all these and more are employed
by Clemente to illuminate this
seafaring tale.*

Clemente's "illustrated" version of the book is, without doubt, one of the most beautiful books the 20th century has produced. On unbound, luminous, hand-made Japanese "kozo" paper, the lithographs, when displayed in groups, take on an unsurpassed visual lyricism, an effect that is not soon forgotten.

– Mark Henshaw, *Off the Page: Contemporary Artist's Books from Picasso to Clemente*. National Gallery of Australia, on-line newsletter no. 24, Summer 2000–2001 (accessed 2 September 2009).

59. Arthur Rimbaud (*trans.* Paul Schmidt), A SEASON IN HELL

The Limited Editions Club, New York, 1986

Photographs
by Robert Mapplethorpe
(1946–1989).

1,000 copies.

Designed by Benjamin Schiff, printed
from Perpetua type at Wild Carrot
Letterpress on Magnani mould-
made paper, photographs printed as
dust-grained photogravures by Jon
Goodman and Peter Pettengill.

11⁵/₁₆ x 7¾ in.

*The matching of Rimbaud and
Mapplethorpe – two artists who
pushed the boundaries of what was
"acceptable" for society in their time –
is inspired. The rich photogravure
prints, soft mould-made paper, and
thick leather binding make for a
sensuously appealing volume.*

ARTHUR RIMBAUD

A SEASON IN HELL

TRANSLATED BY PAUL SCHMIDT

WITH PHOTOGRAVURES BY
ROBERT MAPPLETHORPE

THE LIMITED EDITIONS CLUB

The images in this edition illuminate the text with a shared knowledge of the passage through the dark side of the soul.... To quote the Brooklyn Museum catalog where the photogravures were exhibited in their annual survey of fine American prints – "The eight images in this livre d'artiste *do not so much illustrate Rimbaud's poem as they evoke the mystical, nocturnal melancholy that characterizes the work. ...Daniel Keleher at Wild Carrot Letterpress shows himself again as a printer of the highest integrity.... This book marks the first collaboration between Daniel Keleher and Jon Goodman. Goodman is one of the few craftsmen in the world able to make dust-grain photogravure plates on the level of quality achieved in this edition.... The consistent quality of the printing deserves special admiration, considering the delicate tonal changes and richness which make this technique so luxurious...." We are happy to offer this book: it is a loving and painstaking collaboration between artists and craftsmen.*

– From *The Limited Editions Club Letter*, no. 545, May 1986.

*

60. Pier Paolo Pasolini, Luisa Famos, and Andri Peer, POESIAS RUMANTSCHAS

Edition Gunnar A. Kaldewey, Poestenkill, New York, 1987

Drawings with collage
by Not Vital
(b. 1948).

62 copies: 10 deluxe.

Designed by Gunnar Kaldewey,
printed from Futura type on
handmade Japanese cedar tree
bark paper.

19¼ x 12⅛ in.

*With all books the paper is a major
factor in the overall effect of the volume.
In this case the unusually raw, uneven,
dark stock used is an ideal background
for Not Vital's primal, almost entirely
black graphics.*

142

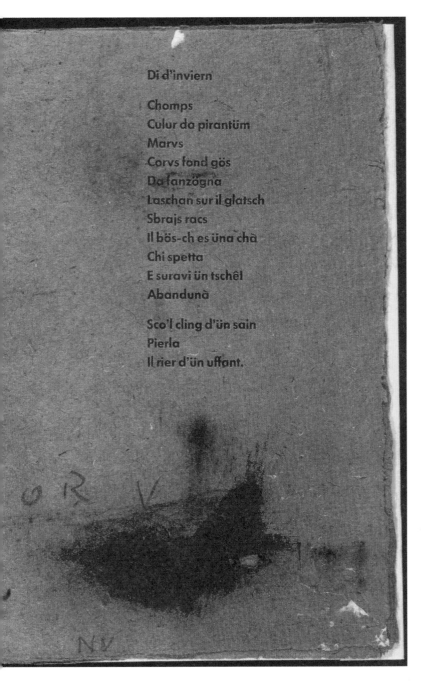

For Volume 12 in the Edition Kaldewey series, Not Vital chose three poems written in or derived from his native language of Rhaeto-Romansch. His dialogue with them took the form of original drawings, collages, and rough markings replicated more or less in the various copies of the edition resulting, in Robert Rainwater's words, "in a book as object made of evocative materials and commanding imagery" (The Print Collector's Newsletter).

– Elizabeth Phillips and Tony Zwicker, *The American Livre de Peintre*. New York, The Grolier Club, 1993.

61. Tu Fu (*trans.* Kenneth Rexroth), THIRTY-SIX POEMS

Peter Blum Edition, New York, 1987

Etchings
by Brice Marden
(b. 1938).

940 copies: 140 are specially bound
and contain one signed etching.

Designed by Jerry Kelly, printed
letterpress from Arrighi and Romulus
types on Arches paper by Wild
Carrot Letterpress. Etchings printed
by Jennifer Melby, duotone offset
illustrations printed by E. H. Roberts
on Mohawk Superfine paper.

9½ x 7 in.

*Marden's work from this period was
influenced by Asian art; his etchings
make a seamless combination with
Tu Fu's poetry. The text was printed
by Wild Carrot Letterpress under the
direction of Daniel Keleher, one of the
leading letterpress shops in the country
(Wild Carrot also printed nos. 59, 65,
71, and 74).*

Thirty-six Poems by

TU FU

translated by

KENNETH REXROTH

with twenty-five Etchings by

BRICE MARDEN

Peter Blum Edition New York
MCMLXXXVII

Brice Marden contributed only a single etching and aquatint to serve as the frontispiece for this volume. Nevertheless, the delicate rhythm of the work is in harmony with the poems of the eighth-century Chinese poet Tu Fu. For Marden, working in etching is a natural extension of his creative process. He has explained that "etching, you know, has a more physical resistance to it than drawing. For me etching becomes something between drawing and painting."

– Robert Flynn Johnson, *Artists' Books in the Modern Era, 1870–2000.* [San Francisco], Fine Arts Museum of San Francisco, 2001.

62. Stephen King, MY PRETTY PONY

Library Fellows of the Whitney Museum of American Art, New York, 1988

Lithographs and silkscreen prints
by Barbara Kruger
(b. 1945).

250 copies.

Picture layout by Barbara Kruger.
Lithographs printed by Derrière
l'Etoile, silkscreen prints by Pinwheel.
Typography by Jerry Kelly in Century
Schoolbook type, printed at The Press
of A. Colish on Rives paper.

20 x 13½ in.

King's story, with its colloquial language, goes well with Kruger's images, in which she juxtaposes the dramatic photography and extra bold sans serif italic fonts of mass market advertising. The no-nonsense Century Schoolbook type, based on the font designed for The Century *magazine, reflects the theme.*

"Good. Keep your eye on it. When it gets up to the top, you holler 'Go!' at me. Understand?"

He nodded.

"Okay. When it gets there, you just let her go, Gallagher."

Banning frowned down at the watch with the deep seriousness of a mathematician approaching the conclusion of a crucial equation. He already understood what Grandpa wanted to show him, and he was bright enough to understand the proof was only a formality . . . but one that must be shown just the same. It was a rite, like not being able to leave church until the minister said the benediction, even though all the songs on the board had been sung and the sermon was finally, mercifully, over.

When the second hand stood straight up at twelve on its own separate little dial (Mine, he marveled. That's my second hand on my watch), he hollered *"Go!"* at the top of his lungs, and Grandpa began to count with the greasy speed of an auctioneer selling dubious goods, trying to get rid of them at top prices before his hypnotized audience could wake up and realize it was not just bilked but outraged, had been somehow induced to purchase sham for specie.

"One-two-thre' fo'-fi'six-sev' neight-nine-ten'leven," Grandpa chanted, the gnarly blotches on his cheeks and the big purple veins on his nose beginning to stand out again in his

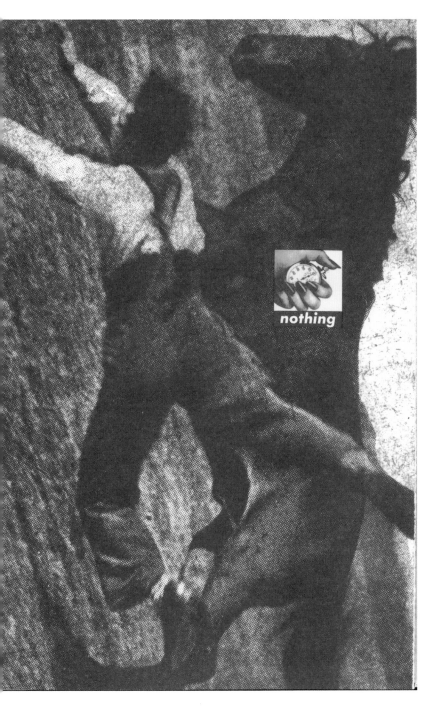

... I proposed that we produce a series of books with new work by artists and writers that would explore the arts of the book. Artists, working with designers and printers, would control the design and structure of the book. . . . From 1982 to 2000 I produced and edited one annual or biannual fine press publication for the Library Fellows. As I was young and inexperienced, the choices of artists and writers for the first books in the series were guided with approvals from the members of the Library Fellows. . . . I learned a great deal from our first designer and printer, Gabriel Rummonds. . . . I invited [Barbara Kruger] to lunch to ask her what she might imagine. She almost immediately suggested Stephen King. It made sense: his work is emphatic and of the wider culture that Barbara's work simulated, critiqued, reconsidered, and sometimes just reveled in.

– May Castleberry, in *Splendid Pages.* Toledo and New York, Toledo Museum of Art and Hudson Hills Press, 2003.

147

63. Harry Mathews, SINGULAR PLEASURES

Grenfell Press, New York, 1988

Lithographs
by Francesco Clemente
(b. 1952).

350 copies: 26 bound in full leather.

Designed by Leslie Miller, printed
letterpress from Bembo types cast
by Michael and Winifred Bixler at the
Grenfell Press, lithographs printed by
Joe Petruzzelli and Maurice Sanchez.

8⅜ x 5½ in.

*The soft beige Japanese paper works
perfectly with Clemente's lithographs,
which appear to be absorbed into the
pages. The letterpress printing of the
type, with its depth of impression into
the paper, is also a sympathetic choice.*

Thirty-eight, divorced, mother of two sons, a woman is masturbating in her bedroom in Adelaide with a thick, supple dildo. She has resorted to the instrument after weeks of general chastity and is now using it to achieve her sixth consecutive orgasm. First she had simply rubbed its tip back and forth over her clitoris; then she had begun working the tip between the lips of her vagina while continuing to stroke her clitoris with its shaft; next, she had gone deeper, only touching her clitoris occasionally; after that, lying on her back with knees raised, she had thrust the instrument even farther inside her; she has just finished penetrating her vagina from behind, resting on her knees and one hand, with her free hand passed back between her legs; and she is now, finally—kneeling, her buttocks on her heels, her hands holding the massive body securely inside her— snapping her pelvis against it with a dancer's precision and strength. Soon she will put the dildo away in a shoebox on the top shelf of her closet and go back to correcting term papers.

Mathews's sixty-one short vignettes on masturbation are perhaps paradoxically paired with Clemente's watercolors, which themselves do not obviously relate to the text. Instead, the illustrations are curious and charming, portraying plants, animals, and various objects, rather than acts of masturbation. Since an exact visual interpretation of the text could have easily been viewed as hypersexual, Clemente's choice to illustrate these vignettes in such a whimsical way emphasizes the fact that the prose is not meant to be erotic, and instead should be interpreted as playful and humanistic.

– Mehera Bonner

64. Ernest Hemingway, THE OLD MAN AND THE SEA

The Limited Editions Club, New York, 1988

Photographs
by Alfred Eisenstaedt
(1898–1995).

600 copies.

Hand-pulled photogravure is a labor-intensive printing technique, but it is ideal for the reproduction of detailed photographs such as these.

Designed by Benjamin Schiff, printed letterpress from Romulus type at the Typostudio Schumacher-Gebler in Munich on Magnani paper from Pescia, Italy. Hand-pulled photogravures by Jon Goodman, Sara Krohn, and Robert Townsend.

10⅞ x 14⅝ in.

ing, thrusting all-swallowing jaws. But that was the location of the brain and the old man hit it. He hit it with his blood mushed hands driving a good harpoon with all his strength. He hit it without hope but with resolution and complete malignancy.

The shark swung over and the old man saw his eye was not alive and then he swung over once again, wrapping himself in two loops of the rope. The old man knew that he was dead but the shark would not accept it. Then, on his back, with his tail lashing and his jaws clicking, the shark plowed over the water as a speedboat does. The water was white where his tail beat it and three-quarters of his body was clear above the water when the rope came taut, shivered, and then snapped. The shark lay quietly for a little while on the surface and the old man watched him. Then he went down very slowly.

"He took about forty pounds," the old man said aloud. He took my harpoon too and all the rope, he thought, and now my fish bleeds again and there will be others.

He did not like to look at the fish anymore since he had been mutilated. When the fish had been hit it was as though he himself were hit.

But I killed the shark that hit my fish, he thought. And he was the biggest *dentuso* that I have ever seen. And God knows that I have seen big ones.

It was too good to last, he thought. I wish it had been a dream now and that I had never hooked the fish and was alone in bed on the newspapers.

"But man is not made for defeat," he said. "A man can be destroyed but not defeated." I am sorry that I killed the fish though, he thought. Now the bad time is coming and I do not even have

66

Besides studies of personalities, [Eisenstaedt] has photographed nature in all her moods, especially at the seashore. Which is what brought him to Cuba and a near sunstroke in 1952 – all because Life [magazine] had to have an Eisenstaedt photograph for the cover of the issue containing the first publication of The Old Man and the Sea. *How fortunate for The Limited Editions Club that for nearly forty years all the negatives have been preserved! – and that they have been made available for this unprecedented edition of a Hemingway masterpiece.*

– From *The Limited Editions Club Letter,* 1988.

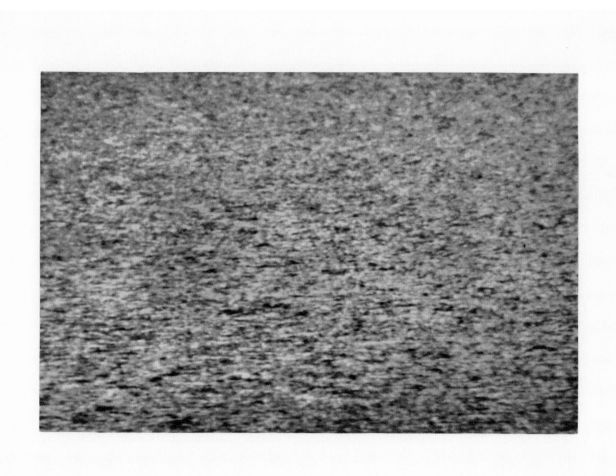

65. Jalaluddin Mohammad Rumi (*trans.* Zahra Partovi), THE REED

Vincent FitzGerald & Company, New York, 1989

Etchings with hand coloring
by Susan Weil
(b. 1930).

50 copies.

Designed by Vincent FitzGerald
and Jerry Kelly, printed from Diotima
type at Wild Carrot Letterpress,
with title page printed at the Kelly-
Winterton Press, etchings printed by
Shigemitsu Tsukaguchi, on J. B. Greene
and Dieu Donné papers.

9½ x 6½ in.

If you pour an ocean into a jug
You can fit no more than one day's portion

Yet the eyes of greed are never satisfied, not seeing
That the oyster bears no pearl till it is content

And that one whose garment is torn on the road
 to love

Becomes free at last of all defects.

*FitzGerald has published dozens of
books of the poetry of the Persian
mystic poet Rumi, in translation by
Zahra Partovi, in combination with
artwork by a wide range of artists.
In this edition of* The Reed, *etchings
by Susan Weil are hand colored with
handcut shapes.*

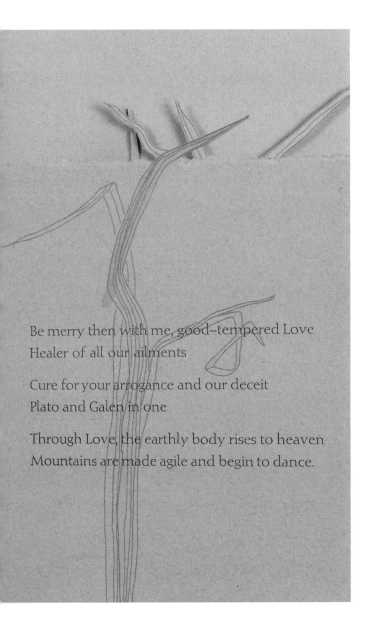

Be merry then with me, good-tempered Love
Healer of all our ailments

Cure for your arrogance and our deceit
Plato and Galen in one

Through Love, the earthly body rises to heaven
Mountains are made agile and begin to dance.

Among the most extraordinary of [Vincent FitzGerald's] Rumi editions is The Reed *illuminated by Susan Weil. The artist produced a cycle of some two hundred small paintings of blades of grass.... Weil brought these grass "portraits" to FitzGerald who realized they complemented Rumi's famous opening soliloquy in the Masnavi. In Persia, the reading of this poem is often accompanied by a simple reed instrument, as if, say the Persians, "the grass is talking."* The Reed *was conceived as a folded accordion edition, cut and printed on both sides. Weil created line etchings for the first half of the book, which contains the English translation, and delicate mezzotints for the flip side where the Persian text is written from right to left. When closed, this extremely subtle book suggests a jungle of grasses.*

– Donna Stein, *A Catalogue Raisonné of the First 26 Books Published by Vincent FitzGerald & Company, 1981–1992.* Munich, Lyric-Kabinett, and New York, The Franklin Furnace, 1992.

66. Samuel Beckett, NOHOW ON

The Limited Editions Club, New York, 1989

Aquatints
by Robert Ryman
(b. 1930).

550 copies.

Designed by Benjamin Schiff from
Bodoni type printed letterpress by
Shagbark Press, plates by Wingate
Studio and Renaissance Press.

10⅝ x 7¹⁄₁₆ in.

fallen she makes for home. Home! As straight as were
it to be seen.

Was it ever over and done with questions? Dead the
whole brood no sooner hatched. Long before. In the
egg. Long before. Over and done with answering. With
not being able. With not being able not to want to
know. With not being able. No. Never. A dream. Ques-
tion answered.

What remains for the eye exposed to such condi-
tions? To such vicissitude of hardly there and wholly
gone. Why none but to open no more. Till all done.
She done. Or left undone. Tenement and unreason.
No more unless to rest. In the outward and so-called
visible. That daub. Quick again to the brim the old
nausea and shut again. On her. Till she be whole. Or
abort. Question answered.

The coffer. Empty after long nocturnal search.
Nothing. Save in the end in a cranny of dust a scrap
of paper. Jagged along one edge as if torn from a diary.

80

*Minimalist art by Ryman, relying to a
good extent on the texture of the prints,
is a perfect match for Beckett's spare,
modernist prose.*

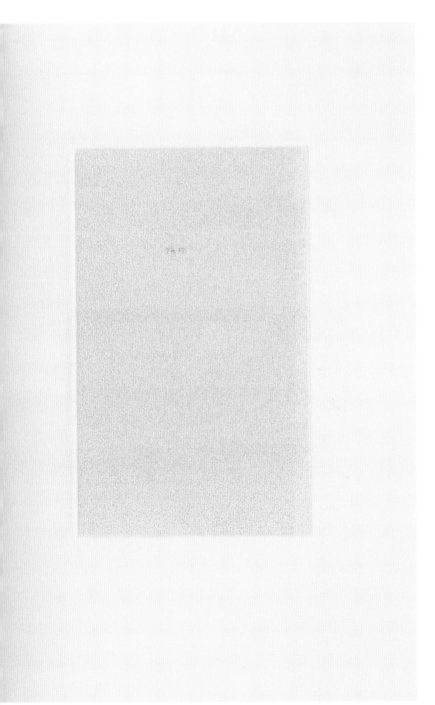

The serene, faintly visible white paintings, drawings, and prints of Ryman's Minimalist oeuvre have concentrated and focused attention on incidents within their spaces. His subtle, but visually intriguing, aquatints are placed within Beckett's set of three texts, one of which, "Worstword Ho," is written in a kind of stuttering street repartee, punctuated throughout with the phrase "Nohow On."

– Riva Castleman, *A Century of Artists Books*. New York, The Museum of Modern Art, 1994.

67. Mark Strand, THE CONTINUOUS LIFE

The Windhover Press, Iowa City, 1990

Woodcuts
by Neil Welliver
(1929–2005).

225 copies.

Designed and printed by Kim Merker
at Windhover Press from Spectrum
type on handmade paper specially
manufactured for the Windhover
Press.

13½ x 10 in.

*One of the last books created by
master printer Kim Merker, this was
produced at a time when he explored
the possibilities of combining art and
words (most of Merker's earlier books
were not illustrated). Merker, who
spent his printing career in Iowa, was a
student of Harry Duncan (see no. 53).*

156

XVI ORPHEUS ALONE

It was an adventure much could be made of: a walk
On the shores of the darkest known river,
Among the hooded, shoving crowds, by steaming rocks
And rows of ruined huts half buried in the muck;
Then to the great court with its marble yard
Whose emptiness gave him the creeps, and to sit there
In the sunken silence of the place and speak
Of what he had lost, what he still possessed of his loss,
And then, pulling out all the stops, describing her eyes,
Her forehead, where the golden light of evening spread,
The curve of her neck, the slope of her shoulders, everything
Down to her thighs and calves, letting the words come,
As if lifted from sleep, to drift upstream,
Against the water's will, where all the condemned
And pointless labor, stunned by his voice's cadence,
Would come to a halt, and even the crazed, dishevelled
Furies, for the first time, would weep, and the soot-filled
Air would clear just enough for her, the lost bride,
To step through the image of herself and be seen in the light.
As everyone knows, this was the first great poem,
Which was followed by days of sitting around
In the houses of friends, with his head back, his eyes
Closed, trying to will her return, but finding
Only himself, again and again, trapped
In the chill of his loss, and, finally,
Without a word, taking off to wander the hills
Outside of town, where he stayed until he had shaken
The image of love and put in its place the world
As he wished it would be, urging its shape and measure
Into speech of such newness that the world was swayed,

*Mark Strand had not published a book
in ten years, though he's a great poet.
We were in contact and he told me he
had a book that was coming out from
a trade publisher. . . . He asked me if I
would be interested in doing a limited
edition of some of the poems before
the trade edition came out. . . . I said
I'd love to, especially after I saw the
poems, which are wonderful. . . . Neil
Welliver is a friend of Mark's; he's a
neo-realist painter who lives in Maine.
He and Mark and their families own
a house together in Ireland. He agreed
to do drawings and have them made
into woodcuts for the book. I sent him
blank pages to show him the size of the
sheet we would print on and where the
margins would be.*

– Kim Merker, in *Printing & the Mind
of Merker*. New York, The Grolier Club,
1997.

*

68. Bradford Morrow, A BESTIARY

Grenfell Press, New York, 1990

Prints in various media
by eighteen artists:
Gregory Amenoff (b. 1948)
Joe Andoe (b. 1955)
James Brown (b. 1952)
Vija Celmins (b. 1939)
Louisa Chase (b. 1951)
Eric Fischl (b. 1948)
Jan Hashey (b. 1938)
Michael Hurson (b. 1941)
Mei Kendrick (b. 1949)
James Nares (b. 1953)
Ellen Phelan (b. 1943)
Joel Shapiro (b. 1941)
Kiki Smith (b. 1954)
David Storey (b. 1948)
Michelle Stuart (b. 1938)
Richard Tuttle (b. 1941)
Trevor Winkfield (b. 1944)
Robin Winters (b. 1950)

100 copies.

Designed by Leslie Miller and
Bradford Morrow, printed by Michael
and Winifred Bixler from Centaur
type on Somerset paper.

14⅞ x 10¾ in.

*Careful printing by various methods
highlights this modern take on an old
theme: a bestiary containing artistic
and literary interpretations of a wide
variety of animal life.*

VIJA CELMINS

Before the dawn of history, when the earth was still flat and the oceans ran out to the edges and fell off into space, back so far in time the sun had not yet risen, the world was a very dark place, so dark that the sea and sky seemed the same. In that olden era the whale roved the wind, forsaking the sea, as he had no desire to be wet. He ranged through the unlit clouds with birds now long extinct, some of which looked like forks and spoons, some like staple guns. He basked in moonglow which darkened his skin to a pale gray, and stargazed, and bothered no one else who made his home in the heavens. Only the mariners who set forth from the land to discover the ends of the earth found the whale to be a problem. What little light gave from the moon and stars, light by which they tied their ancient knots and fixed their rigging, was obscured whenever the great, slow blimp of a whale passed over. Enough, said these sailors, and brought him down with nets, hoping to drown him in the ocean beneath their bow. What happened next we all know, as now of course the whale we think of as only in the sea. True, he didn't notice the difference much, and came to love the feeling of water on his flesh. The splash he made when the mariners caught him caused the waterfall edges of the earth to crumble, and the ocean rolled in rivers, and the earth became round. In this way, without even meaning to, the whale behaved less like a blimp or bird or any other thing which roams the sky than a god, for he helped to fashion the world in his own image.

A bestiary is a medieval book of prose or verse, often illustrated, describing with allegorical, moralizing commentary the appearance and habits of real and imaginary creatures. In a postmodern updating of this traditional form, the Grenfell Press joins Bradford Morrow's ironic and thoughtful prose with many of the leading artists of the late 1980s. Each artist created two prints for the resulting menagerie that includes obvious creatures such as elephants, owls, horses, and frogs, and unexpected ones such as plankton, hummingbirds, beavers, and yaks.

– Robert Flynn Johnson, *Artists' Books in the Modern Era, 1870–2000*. [San Francisco], Fine Arts Museum of San Francisco, 2001.

69. Arthur Miller, HOMELY GIRL, A LIFE

Peter Blum Edition, New York, 1992

Ink drawings (printed by offset lithography with letterpress background tint in the regular edition) and 8 photographs printed by offset lithography by Louise Bourgeois
(1911–2010).

1,300 copies: 100 deluxe with original drypoints, specially bound.

Designed by Klaus Baumgartner and Peter Blum, printed from Emerson type at the Stinehour Press. Drypoints printed by Harlan & Weaver (deluxe edition).

11½ x 8¹¹⁄₁₆ in.

Several printing techniques are featured in this book, including two color text (gray and red) in volume II, which also includes reproductions of color photographs; and in volume I a delicate cream tint behind reproductions of Bourgeois's drawings (which are printed as drypoints in the deluxe issue).

160

VI

The creaky elevator door opened one afternoon and she saw standing before it a handsome man in his forties – or possibly his early fifties, with a walking stick in one hand and a briefcase in the other. Janice noted his oddly straight-backed walk as he entered the elevator, and only realized he was blind when he stopped hardly six inches from her, and then turned himself to face the door by lifting his feet slightly instead of simply swivelling about. There was a shaving cut on his chin.

"Going down, aren't we?"

"Yes, down." For one instant he stared sightless, directly into her face. Her chest contracted. "He doesn't see me!" she cried out inwardly. A freedom close-by, a liberation swept her up. The door opened at the lobby.

He walked straight out and across the tiled floor to the glass doors to the street. She hung on behind him and quickly came around to push the doors open for him, "May I help you?"

"Don't bother. But thanks very much."

He walked into the street, turning directly right toward Broadway and she hurried to come up alongside him. "Do you go to the subway? I mean, that's where I'm going if you'd like me to stay with you."

"Oh, that'd be fine, yes. Thank you, although I can make it myself."

"But as long as I'm going, too . . ."

She walked beside him, surprised by his good pace. What life in his fluttering eyelids! It was like walking with a sighted man but some undefined feeling of freedom was threatening to bring tears of happiness to her eyes. She heard her own voice, which seemed to fly out of her mouth with all the open innocence of a young girl's.

His voice had a dry flatness as though not often used. "Have you lived in the hotel long?"

"Since March." And added without a qualm, "Since my divorce." He nodded. "And you?"

"Oh, I've been there for five years now. The walls on the twelfth floor are just about soundproof, you know."

26

The concept of the livre d'artiste as a dialogue between artist and author prompted by a publisher is elegantly embodied in these two volumes, in which the same story is printed twice but with telling differences. In volume I, "Arthur Miller" appears first on the title page and the images – doodle-like ballpoint-pen drawings of flowers and what resembles both a mountain range and a fever chart – face black letterpress type. In volume II, "Louise Bourgeois" comes first; the type is gray with passages about sight picked out in red; and a series of full-color medical photographs of pairs of eyes in extreme close-up appear on smaller-size paper, hiding the print behind and requiring one to lift them to read the text. In this previously unpublished story, love is literally blind, and between a handsome blind man and the "homely girl." The hues and distortions of the eyes seem to vary with the emotions of the heroine, building to a climax with the hero's death. While dramatizing the reader's acts of seeing—and sight and insight generally – Bourgeois's imagery and Blum and Baumgartner's design give the Upper West Side milieu of Miller's story a poetic, even fairy-tale dimension.

– Anne H. Hoy

70. Harry Rand, THE CLOUDS

The Dov Press, Washington, DC, 1996

Lithographs
by Elaine Kurtz
(1928–2003).

120 copies: 55 with an additional suite
of the lithographs.

Designed by Jerry Kelly, printed
letterpress from Minion type on Rives
BFK paper at the Stinehour Press,
lithographs printed at Solo Press.

14 x 10 in.

Kurtz's grisaille lithographs are en-
hanced by textures (using mica, sand,
and other unlikely substances). The
blacks-whites-and-grays of the prints
are reflected in the gray printing of
the text with display words printed in
black – allusions to the tones of clouds.

THE CLOUDS

Words by Harry Rand

✳

Images by Elaine Kurtz

Published by The Dov Press

Washington, DC 1996

The Clouds *blends different voices of many personalities in numerous short observations – like movements in music. It is at times witty, elegaic, confiding or satiric. It is a prose poem, a short story, epigraphs, poetry, dialogue, and much else. The stories and epigrams describe humanity and the world – they are about the past and the future, the beginning of the world and its end. . . .* The Clouds *was the only finely printed* livre d'artiste *book that [Elaine Kurtz] illustrated. . . . Many images required multiple plates and the artist's hand appliqué of color and mica.*

– From the prospectus

71. Jalaluddin Mohammad Rumi (*trans.* Zahra Partovi), DIVAN-E-SHAMS

Vincent FitzGerald & Company, New York, 1996

Prints in various media
by fifteen artists:
Joan Busing (b. 1935)
Sandy Gellis (b. 1940)
Elizabeth Harrington (b. 1935)
Bernard Kirschenbaum (b. 1924)
Ted Kurahara (b. 1925)
James Nares (b. 1953)
Dorothea Rockburne (b. 1932)
Betye Saar (b. 1926)
Annette Senneby (b. 1951)
Michelle Stuart (b. 1940)
Peter Thomson (1936–2007)
Judith Turner (b. 1939)
Marjorie Van Dyke (b. 1956)
Joan Vennum (b. 1931)
Susan Weil (b. 1930)

50 copies.

Designed by Vincent FitzGerald
and Jerry Kelly, printed from Zapf
Renaissance type at Wild Carrot.
Letterpress on Rives BFK and Dieu
Donné papers, with calligraphic
title page and initials by Jerry Kelly.
Images printed by various methods,
including lithography, etching,
silkscreen, and computer plotter
drawing.

14 x 12½ in.

A great diversity of graphic techniques
(silkscreen, etching, lithography, even
computer plotting) are held together by the
consistent text placement and the typogra-
phy in Zapf Renaissance roman type.

Within the membranes of blood
Love possesses a rose garden
Where lovers keep company with its unsurpassed beauty.
Reason says there are six directions
And beyond that limit no more.
Love says there are infinite ways, yes
I have traveled them often.
Reason finds a market and begins trading
Love sees beyond the one,
Infinitely many more.
As the inexplicable Mansur, trusting the soul of love
Abandons the altar to die on the gallows.

MICHELLE STUART

164

The most remarkable biographical information about Jalaluddin Rumi's life is not the appearance and disappearance of the mystic Shams, but Rumi's imperative and conscious decision to make a change in his career from a Sufi teacher to a poet. Here the medium is truly the message: the most successful Sufi teacher of all times with countless devoted followers chooses to communicate through the path of poetry. This masterful poet combines philosophy, mysticism, and psychology in a language so piercing as to enter the realm of music. It is this element more than any other which has made Rumi's poetry so irresistible to readers for over seven hundred years, even through the filter of translation.

– Zahra Partovi, in *Themes & Variations: The Publications of Vincent FitzGerald & Company.* New York, Columbia University, 2000.

72. Robert Creeley, EDGES

Peter Blum Edition, New York, 1997

Etchings
by Alex Katz
(b. 1927).

60 copies: 30 issued loose in sheets.

Designed by Jerry Kelly, with text
printed from Emerson type on
Rives paper by Carol Sturm at Nadja,
etchings printed by Simmilink/
Sukimoto Editions.

14⅞ x 12½ in.

E xpectably slowed yet unthinking
of outside when in, or weather

as ever more than there when
everything, anything, will be again

*Both the prints and texts occupy an
unusually small part of the page. Both
are carefully placed to perform various
duets on the two-page spreads.*

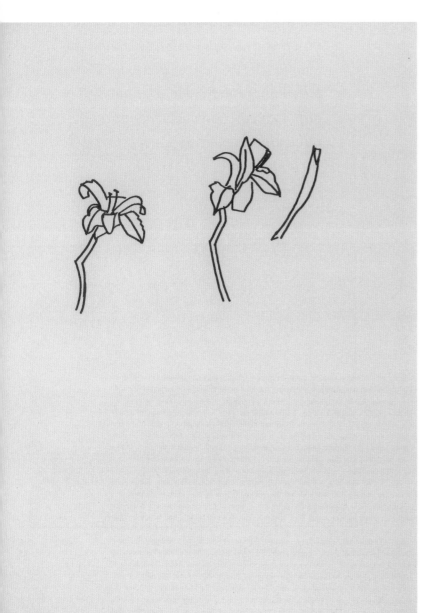

Edges *combines stanzas from Creeley and etchings from painter Alex Katz, both inspired by the Maine landscape of their neighboring summer homes. Like many of the projects, Edges has been issued in both bound and un-bound versions, offering both the intimate experience of the turned page and the more publicly accessible experience of the framed print.*

– Elizabeth Licata, *Robert Creeley's Collaborations. A History.* Web catalogue: http://webyarns.com/elizspeak/16creeley2.html.

73. Jean Toomer, CANE

Arion Press, San Francisco, 2000

Woodcuts
by Martin Puryear (b. 1940).

426 copies; 26 with an extra suite of the woodcuts.

Designed by Andrew Hoyem, printed in Times New Roman Bold and Lucian Bold on Hahnemuhle Biblio and handmade Kitakata paper at the Arion Press.

13½ x 14⅞

Puryear's woodcuts, created as white lines on a textured, near black background, are balanced by the bold weight of the Times New Roman text font and Lucian Bold display type. The woodblocks are carefully printed on Japanese paper to reveal the graphic grain of the wood.

Fern

Face flowed into her eyes. Flowed in soft cream foam and plaintive ripples, in such a way that wherever your glance may momentarily have rested, it immediately thereafter wavered in the direction of her eyes. The soft suggestion of down slightly darkened, like the shadow of a bird's wing might, the creamy brown color of her upper lip. Why, after noticing it, you sought her eyes, I cannot tell you. Her nose was aquiline, Semitic. If you have heard a Jewish cantor sing, if he has touched you and made your own sorrow seem trivial when compared with his, you will know my feeling when I follow the curves of her profile, like mobile rivers, to their common delta. They were strange eyes. In this, that they sought nothing—that is, nothing that was obvious and tangible and that one could see, and they gave the impression that nothing was to be denied. When a woman seeks, you will have observed, her eyes deny. Fern's eyes desired nothing that you could give her; there was no reason why they should withhold. Men saw her eyes and fooled themselves. Fern's eyes said to them that she was easy. When she was young, a few men took her, but got no joy from it. And then, once done, they felt bound to her (quite unlike their hit and run with other girls), felt as though it would take them a lifetime to fulfill an obligation which they could find no name for. They became attached to her, and hungered after finding the barest trace of what she might desire. As she grew up, new men who came to town felt as almost everyone did who ever saw her: that they would not be denied. Men were everlastingly bringing her their bodies. Something inside of her got tired of them, I guess, for I am certain that for the life of her she could not tell why or how she began to turn them off. A man in fever is no trifling thing to send away. They began to leave her, baffled and ashamed, yet vowing to themselves that some day they would do some fine thing for her: send her candy every week and not let her know whom it came from, watch out for her wedding-day and give her a magnificent something with no name on it, buy a house and deed it to her, rescue her from some unworthy fellow who had tricked her into marrying him. As you know, men are apt to idolize or fear that which they cannot understand, especially if it be a woman. She did not deny them, yet the fact was that they were denied. A sort of superstition crept into their consciousness of her being somehow above them. Being above them meant that she was not to be approached by anyone. She became a virgin. Now a virgin in a small southern town is by

22 ✦ CANE

The marriage in Cane *of author Jean Toomer (1894–1967) and sculptor-printmaker Martin Puryear sheds different light on each. In the narratives and poems of the novel, Toomer's imagined "voices" are specific, passionate, pained, and often first-person as he recreates mostly black perceptions of race relations in small-town 1920s Georgia. Puryear's incised woodcuts, on the other hand, are almost entirely abstract, though a simplified face, a railroad track, and the like can be identified. Yet these curvilinear images are more particular than Puryear's monumental wood sculptures, while they enlarge the metaphors of Toomer's texts. When publisher Andrew Hoyem invited Puryear to illustrate a book, each reportedly hoped the other had* Cane *in mind. The pairing of African Americans of two generations reminds us that the question of evaluating color in art by the artist's color remains alive. But this may be the least of the insights afforded by this evocative* livre d'artiste. – Anne H. Hoy

74. Aeschylus (*trans.* Ted Hughes), THE ORESTEIA

Gehenna Press, Northampton, MA, 2002

Woodcuts
by Leonard Baskin
(1922–2000).

60 copies: 10 with an additional suite
of the prints.

Designed by Leonard Baskin from
Centaur type printed by Wild Carrot
Letterpress, woodcuts printed at the
Horton Tank on Zecchi paper.

16⅛ x 12¼ in.

Only let today
Bring blessings greater than any day yet.
Those Greeks who have come to ask
The oracle a question:
Let them draw lots.
As Apollo breathes through me, I shall speak.

Priestess goes in to shrine. She staggers out again, with shrieks.
A horrible vision! No, it wasn't a vision.
I can hardly stand.
Hold me up. It wasn't a vision.
Oh, too much for an old woman–
I'm weaker than a baby.
I went in,
Towards the shrine.
The inner shrine is hung with the wreaths
of supplicants.
It is centred on the stone of the earth's centre.
The omphalos. The holiest of all stones.
On that stone a strange man is sitting.
A man dipped in blood,
His whole body varnished with blood,
And he grips a sword, also bloody,
As though his grip had locked on the hilt
And he could not relax it.
His eyes stare, as if he could not blink
Or dare not blink.
Yet he knows where he is–
❋ Fresh olive leaves,
❋ With white new wool twisted among them,
❋ Are bound around his head,

2

*Baskin was a master of the arts of the
book. For this, one of the last produc-
tions of his Gehenna Press, expression-
istic woodcuts illustrate a classic text.
The translation is by Baskin's friend,
the poet Ted Hughes.*

[The Gehenna Press Oresteia] was the final collaboration between Leonard Baskin and Ted Hughes; a relationship which will be regarded as one of the most significant artist/poet pairings of our time. The Bodleian Library in their current quatercentenary exhibition, "Wonderful things from 400 years of collecting: The Bodleian Library 1602–2002," includes the Oresteia. . . .

– Kenneth Shure, director of the Gehenna Press, in an undated letter to Richard Estes, book collector.

75. [Guillermo Kuitca], PURO TEATRO

Edition Jacob Samuel, Santa Monica, CA, 2003

Etchings with chine collé
by Guillermo Kuitca
(b. 1961).

25 copies and 6 artist's proofs.

Typography in Diotima type printed
by Les Ferriss. Plates printed on
Shikibu Gampi paper by Jacob
Samuel, chine colléed onto Rives de
Line paper.

16 x 16¼ in.

*The uncommon Diotima font (used
for the typography of the book you are
now reading), with its lovely design
approaching the hand-drawn letter, is
used to good effect alongside Kuitca's
drawings of theater interiors.*

Guillermo Kuitca

PURO TEATRO

Edition Jacob Samuel
2003

Each print in the suite has a hand-rendered, unnamed theatre interior comprising schematic horizontals (orchestras, mezzanines, and/or balconies), broken up into tiny squares representing seats. In some they are elaborate, with additional box seats and circular piers, implying an interior, old-fashioned and ornate; others feel more modern, with one comprising just a tipped-up set of very abstract grids. Each has its own personality, as if it is an individualized face staring out at the viewer. The plates are small and intimate, with the printing in black on cream-colored Gampi. So many artists today are engaged in architectural fantasy of one sort or another, but Kuitca is the progenitor of the genre. – Art on Paper, April 2003

76. Aimé Césaire,
CAHIER D'UN RETOUR AU PAYS NATAL

Éditions du Solstice, Paris, 2004

Silkscreen prints by
Daniel Buren
(b. 1938).

140 copies (40 not for sale).

Printed from Baskerville type on
specially made Rives BFK paper at
l'Atelier d'Eric Seydoux.

13⅝ x 20½ in.

Parfois on me voit d'un grand geste du cerveau, happer un n
ou une caresse de pluie, ou un prélude du vent, ne vou
outre mesure :

Je force la membrane vitelline qui me sépare d

Je force les grandes eaux qui me ceintur

C'est moi rien que moi qui arrêt
dernière vague du dernier raz-d

C'est moi rien que moi
qui prends langue avec
C'est moi oh, rien q
qui m'assure au c
les premières q

Et maint
au sol
à la

*The hard edges of the die cut shapes
go perfectly with the hard edges of
the silkscreen prints. The die cut pages
provide an opportunity for vivid colors
to be juxtaposed with other colors and
snippets of text as the pages are turned,
a feature uniquely suited to the codex
format. This sequencing of color has
some relation to Albers's work (no. 49).*

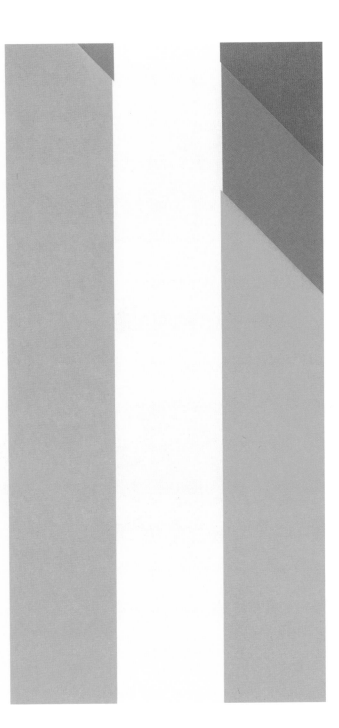

Buren's illustrations exist in opposition to the text of Césaire's Cahier d'un retour au pays natal, *a work whose impact is deeply rooted in lyricism. By using his signature stripe motif, Buren reinterprets the book, dissociating the illustration from the text's inventiveness in lexical and semantic language. The illustrations are freed from their typical role of depicting a story, and they instead offer figurative ambiguity.*

– Mehera Bonner

77. Wislawa Szymborska, RECEIVER

Dieu Donné in partnership with Galamander Press, New York, 2006

Engravings and photogravures by
William Kentridge
(b. 1955).

50 copies.

Text printed by Ruth Lingen from
Garamond type, engravings and
photogravures printed by Randy
Hemminghaus, on various papers
handmade at the Dieu Donné
Papermill.

14½ x 11¾ in.

*Kentridge's dynamic images, together
with the elegance of the specially hand-
made papers, and near-perfect letter-
press printing, form a book that is a joy
to the senses.*

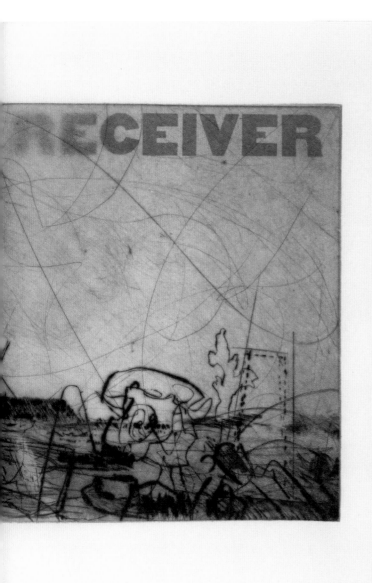

Transformation is a notion that informs both Kentridge's understanding of the process of printmaking and the broader realm of politics. Though he is best known for his films and drawings, his formal training is in printmaking.... Transformation, in both the conceptual and practical senses, has informed the artist's relationship to handmade paper from the outset. Kentridge first worked with Dieu Donné ... in 2002.... "This was about finding the transparency and opacity that we wanted. We needed to find logic in the use of the paper, seeing the texts half through the page," he says. The decision to print some of them on fine translucent abaca represented no small challenge, as Canadian print-maker Randy Hemminghaus recalls with some glee: "The way the paper reacted to slight shifts of humidity or time changes in the process meant that we ended up throwing a lot out. In the end, Kentridge's genius was recognizing how beautiful this would look. The transformations that take place while you look through it – a sense of something beneath the surface, images that are revealed, then hidden again – are almost filmic."

– Catherine Bindman, in *Art on Paper*, March/April 2007.

Afterword

The *Best of Both Worlds: Finely Printed* Livres d'Artistes, *1910–2010* is the first book and exhibition we know of to insist on the importance of production values in the aesthetics of artists' books – on the significance, if not the parity, of designer and publisher with artist and author in the genre. Close to eighty volumes span a hundred years, two thirds from the postwar period. Published to accompany a Grolier Club exhibition in May–July 2011, *The Best of Both Worlds* is consistent with several of the Grolier's catalogues since the 1990s[1] and its founding mission of 1884, to promote "the arts related to the production of books." Is it a call to order in a mob scene of shapeless but fertile activity? Or is it closer to a demand for better vellum as the Vikings surround Iona?

On the one hand, enthusiasm for modern and contemporary book arts as seen in fairs, shows, publications, and symposia seems scarcely dampened by our decade's primal economic and political fears. The 2010 New York Art Book Fair at P.S.1 had some 120 vendors and an attendance of roughly twelve thousand, an increase of twenty percent in both categories over the Fair in 2009.[2] In London in 2008 the Victoria & Albert's exhibition "Blood on Paper: The Art of the Book" united book works from Picasso to Daniel Buren, Anthony Caro, and Damien Hirst and offered a seven-and-a-half-pound catalogue of unbound booklets in a box. The organization by curators Rowan Watson, of the V&A's Word and Image Department, and Elena Foster, of Ivory Press, was intended to show the "remarkable diversity of approaches by contemporary artists" to the book.[3] Chronological surveys took place at the British Library in 2007–8 ("Breaking the Rules," on vanguard books and journals from Apollinaire's *calligrammes* through Surrealism); the Fondation Maeght in 2004 ("De l'écriture à la peinture"); and at the Fine Arts Museums of San Francisco in 2001 ("Artists Books in the Modern Era, 1870–2000"). At New York's Center for Book Arts between 2005 and 2010, government and foundation funding for exhibitions has increased an astonishing fourteen times over.[4]

On the other hand, the decline of production quality in most trade publishing is virtually a cliché among professionals,[5] a condition exacerbated by the rise of e-books. The topic "Is the Book Dead?" has reached TV talk shows, and the issue's currency is powered by the strong annual rate of increase in Kindle and other e-reader sales.[6]

Do digital bestsellers relate to "finely printed *livres d'artistes*"? Perhaps only distantly. While exclusive use of the codex form for pulp fiction and how-to manuals appears justifiably endangered, this book about books – a codex on codices – focuses on volumes for a different audience. That audience is largely a specialist group of connoisseurs and bibliophiles among collectors and art and bookish institutions, as defined simply by the monetary value of the works assembled here. All exceed the cost of the typical art book, that is, a richly illustrated book *about* art. But they generally retail for less than a single one of their artists' prints. Indeed, about one third of these books, which all contain more than one reproduction, retail for under $500 each. Yet technological innovations have revolutionized book production in the past and spurred creative responses transcending the provocation. The Victorians' penny dreadfuls printed from spindly fonts on wood-pulp paper (often with garish chromolithographs) sparked William Morris's reformatory zeal in the 1890s. The post-World II ubiquity of offset printing may have been a factor in promoting photogravure and screen printing by contrast, for their superior reproductive qualities. Just as five-dollar Kodaks encouraged Photo-Secessions of camera artists, the software of the last thirty years and the Facebook pages of today are triggering creative reactions. Whether they acknowledge or defy these mass phenomena, the finely printed volumes in *The Best of Both Worlds* have an admired status in the worlds of publishing and of paintings, prints, and other artworks, notwithstanding their hazy identity for some bookish and artistic audiences.

Uniting the gifts of artist, author, designer, printer, binder, and publisher, *livres d'artistes* showed their best, Riva Castleman writes here (p. 12), when "artists and authors were seriously chummy" in the 1890s–1920s and again in the 1940s–1990s. This raises a point worth stressing: a superior production helps produce the meaning of great writing and great art alike. Whether or not new criteria for judging *livres* are needed, the attempts at definition of the genre in the 1990s may have gone unheard.[7] The strength of the genre – its heterogeneity – is also a weakness: the indifference to production values or ignorance of them (which inspired this catalogue) may derive in part from confusion between *livres d'artistes* and artist's books.

The artist's book was apparently first named in 1973 in an exhibition at Moore College of Art in Philadelphia. The term did not merely translate *livre d'artiste*: the show of some 250 "different types of books made by artists from 1960 to the present" included Xeroxed booklets, works by Ed Ruscha, Dieter Roth, and John Cage, as well as finely produced and thus more expensive editions by Robert Motherwell and David Hockney.[8] Since then, the artist's book has been associated most often with the

Americans' Conceptual and Minimal art expressions, notwithstanding contributions by Fluxus and CoBrA artists: such a product documented purposely ephemeral artworks or stood as an artwork itself, one initiated by the artist. Other kinds of artist's books were generated by members of the studio movement in the 1970s, as print artists and papermakers adopted the codex but also disparate structures in paper and other flexible materials for their experiments. The genre as such attracted semioticians, who seized the opportunity to examine the distinct languages of words and images. They explored with Michel Foucault "the difference and the *différence*, the irreducibility of seeing and saying, showing and telling, display and discourse." And book objects – book-shaped sculptures, one-of-a-kind or in limited editions, with or without texts – interrogated the conventional material identity of the book and its various cultural roles, the nature of written expression, and the seriality of reading for a necessarily interactive viewer.

In these diverse forms and proliferating numbers (marked by over three hundred exhibitions and over seven hundred published works between 1973 and 1988),[9] the literary text took a back seat, and printers, papermakers, and binders braved the onus of craft and hobbyist associations during "the dematerialization of the art object" current in other artistic manifestations. Since the 1970s the artist's book has remained protean, while appealing to vastly different makers and thinkers. It may still do without authors, and there are no benchmarks for production.

By contrast, the *livre d'artiste* dates, in the consensus supported by Jerry Kelly's Introduction here, from Vollard's marriage of Verlaine and Bonnard in *Parallèlement*, 1900, and Kahnweiler's subsequent commissions to Dérain, Picasso, Braque, and others to collaborate with contemporary authors on their original texts. In this history, artist and author share similarly high status and their union is instigated and underwritten by a committed gallerist or publisher, or an individual playing both roles. At its best, the union is served by sympathetic choices of fonts, paper, reproductive methods, and housings – in sum, by equally gifted designers, printers, and binders. The resulting *livres d'artistes* are presented most often, but not always, in art venues – in galleries and museums – rather than libraries or publishers' catalogues alone.

Yet the *livre d'artiste* should not be confused with portfolios of prints by the same artists – though they create in both genres. Hanging *livre d'artiste* pages sequentially on the wall does not duplicate the book's intended effect. Similarly, a *livre d'artiste* image does not live fully in isolation. A spread from a *livre d'artiste* is like a detail from the Unicorn tapestry series: a practical expedient but a potentially misleading shorthand. Lower-cost knockoffs, printed commercially on inexpensive paper,

likewise damage the original book's effect. Most significant, the artist-with-printer and the author are the warp, weft, and thread of a unique fabric: if one is weaker, the strength of the total is compromised. To test this, imagine one of the works in *The Best of Both Worlds* as an e-reader file without images or its other original visual and tactile ingredients. If the meaning of the written content remains substantially unchanged without images and fine production, the work *with* images might better be termed an *illustrated book*, in the logocentric tradition of sacred scrolls and codices. If a book's sensuous and intellectual experience remains relatively untouched by the loss of words, it might better be termed a *book object* or a part of the *artist's book* genre.

In this catalogue, the *livre d'artiste* represents exceptional examples of *The Best of Both Worlds* – a collaboration among artist, author, and printer in which all components are interdependent in creating the meaning and quality of the whole. It seems to me that the term *livre d'artiste* could be helpfully used with this sharper definition. In word order *livre d'artiste* puts the book first; in cultural history it designates the originating collaborations of turn-of-the-century France. Today, its usage can indicate the continuing vitality of such happy unions. In the future it may help us better recognize the next Book of Kells, among other brilliant visual/verbal marriages yet to be made.

Anne H. Hoy

1. Such as *The American Livre de Peintre,* 1993; *A Century for the Century: Fine Printed Books 1900–1999,* 1999; *The Guild of Bookworkers' Centenary Exhibition,* 2006; and *Beyond the Text: Artists' Books from the Collection of Robert J. Ruben,* 2009.

2. Estimate from Milan Hughston, Chief of Library and Museum Archives, Museum of Modern Art, telephone conversation with Anne Hoy, January 10, 2011. See http://nyartbookfair.com/about.php.

3. See text by Rowan Watson at www.vam.ac.uk, accessed January 12, 2011.

4. Alex Campos, Director, Center for Book Arts, reading Annual Reports in telephone conversation with Anne Hoy, January 11, 2011.

5. At the panel discussion "Current Challenges to Fine Printing and Book Design" at the Grolier Club in January 2010, David Godine noted that bindings have been a standard item for cost-cutting for the last twenty-five years, an observation the panel agreed with.

6. Though the sale of e-books amounted to only 3.2% of the second quarter's total book sales in 2010: *Publisher's Weekly,* October 4, 2010.

7. On behalf of the artist's book as a "democratic multiple" in numerous forms, see Johanna Drucker's probing *Artists Books of the Twentieth Century* (New York: Granary Books, 1994).

8. Stefan Klima, *Artists Books: A Critical Survey of the Literature* (New York: Granary Books, 1998), p. 7.

9. The last phrase is that of Elza Adamowicz in "*Etat Present*: The *Livre d'Artiste* in Twentieth-Century France," *French Studies* 63, no. 2 (March–April 2008): 189. This critical summary started me thinking about defining terms on behalf of this catalogue.

PHOTO CREDITS

Every effort has been made to trace copyright owners and photography. The publishers apologize for any unintentional omissions and would be pleased in such cases to add an acknowledgment in future editions.

Ansel Adams © 2010 The Ansel Adams Publishing Rights Trust

Josef Albers © 2010 The Josef and Anni Albers Foundation / Artists Rights Society (ARS), New York. *Photo: NYPL*

Leonard Baskin, courtesy the Estate of Leonard Baskin

Max Beckmann image courtesy National Gallery of Art, Washington. Gift of Mrs. Max Beckmann. © 2010 Artists Rights Society (ARS), New York / VG Bild-Kunst, Bonn

Pierre Bonnard © 2010 Artists Rights Society (ARS), New York / ADAGP, Paris

Lee Bontecou © Lee Bontecou , courtesy of FreedmanArt, New York

Georges Braque © 2010 Artists Rights Society (ARS), New York / ADAGP, Paris

Daniel Buren © 2010 Artists Rights Society (ARS), New York / ADAGP, Paris. *Photo: MoMA*

Alexander Calder © 2010 Calder Foundation, New York / Artists Rights Society (ARS), New York

Massimo Campigli © 2010 Artists Rights Society (ARS), New York / SIAE, Rome

Vija Celmins ©Vija Celmins, courtesy McKee Gallery, New York

Marc Chagall © 2010 Artists Rights Society (ARS), New York / ADAGP, Paris

Francesco Clemente: courtesy Francesco Clemente

Jim Dine © 2010 Jim Dine / Artists Rights Society (ARS), New York

Jean Dubuffet © 2010 Artists Rights Society (ARS), New York / ADAGP, Paris

Max Ernst © 2010 Artists Rights Society (ARS), New York / ADAGP, Paris

Eric Fischl © 1986 Eric Fischl; courtesy of the artist

Antonio Frasconi © Antonio Frasconi; courtesy of the artist

Terry Haass © 2010 Artists Rights Society (ARS), New York / ADAGP, Paris

Jasper Johns © Jasper Johns/Licensed by VAGA, New York, NY

Wassily Kandinsky © 2010 Artists Rights Society (ARS), New York / ADAGP, Paris. *Photo: MoMA*

William Kentridge © William Kentridge, courtesy: Marian Goodman Gallery, New York / Paris

Oskar Kokoschka © 2010 Fondation Oskar Kokoschka / Artists Rights Society (ARS), New York / ProLitteris, Zürich

Lee Krasner: © 1967 The Pollock-Krasner Foundation / Artists Rights Society (ARS), New York

Barbara Kruger courtesy Mary Boone Gallery, New York

Guillermo Kuitca © Guillermo Kuitca

Paul Landacre © Estate of Paul Landacre/Licensed by VAGA, New York, NY

Aristide Maillol © 2010 Artists Rights Society (ARS), New York / ADAGP, Paris

Frans Masereel © 2010 Artists Rights Society (ARS), New York / VG Bild-Kunst, Bonn

Henri Matisse © 2010 Succession H. Matisse / Artists Rights Society (ARS), New York

Joan Miró © 2010 Successió Miró / Artists Rights Society (ARS), New York / ADAGP, Paris

Joan Mitchell © The Estate of Joan Mitchell

Robert Motherwell © Dedalus Foundation, Inc./Licensed by VAGA, New York, NY. *Photo: MoMA*

Pablo Picasso © 2010 Estate of Pablo Picasso / Artists Rights Society (ARS), New York

Arnaldo Pomodoro: © Arnaldo Pomodoro, Milano

Martin Puryear courtesy Donald Young Gallery

Robert Rauschenberg © Robert Rauschenberg/Licensed by VAGA, New York, NY

Man Ray © 2010 Man Ray Trust / Artists Rights Society (ARS), NY / ADAGP, Paris

Georges Rouault © 2010 Artists Rights Society (ARS), New York / ADAGP, Paris

Robert Ryman © 2010 Artists Rights Society (ARS), New York. *Photo: NYPL*

Ben Shahn © Estate of Ben Shahn/ Licensed by VAGA, New York, NY

John Sloan © 2010 Delaware Art Museum / Artists Rights Society (ARS), New York

Edward Steichen, permission of Joanna T. Steichen

Antoni Tàpies © 2010 Fundació Antoni Tàpies / Artists Rights Society (ARS), New York / VEGAP, Madrid

Gunther Uecker © 2010 Artists Rights Society (ARS), New York / VG Bild-Kunst, Bonn. *Photo: MoMA*

Neil Welliver ©Neil Welliver, courtesy Alexandre Gallery, New York

Grant Wood permission of MBI, Inc.

Reproductions from publications of Vincent FitzGerald & Company; courtesy of the publisher

Reproductions from publications of Peter Blum Edition; courtesy of the publisher

Index of artists

Numbers refer to catalogue entry numbers

Index of authors

Numbers refer to catalogue entry numbers

Index of titles

Numbers refer to catalogue entry numbers

Index of printers

Numbers refer to catalogue entry numbers

Index of publishers

Numbers refer to catalogue entry numbers

Set in Diotima types designed by Gudrun Zapf von Hesse, Darmstadt, Germany

Printed and bound by C & C Offset, China

Designed by Jerry Kelly, New York